Americana
at Auction

Americana

E.P. DUTTON · NEW YORK

at Auction

A Pictorial Record of
More Than 700 American Antiques Sold by
Twenty Auction Houses in 1978

Samuel Pennington, Thomas M. Voss, Lita Solis-Cohen

SAMUEL PENNINGTON was born in Baltimore and educated at Phillips Exeter Academy and Johns Hopkins University, where he majored in French. He served for twenty-one years in the United States Air Force as a navigator, bombardier, and plans officer. In 1973 he and his family started the *Maine Antique Digest*, a publication of nationwide circulation that covers the marketplace for Americana. He also writes a weekly column on antiques for the *Bangor Daily News*.

THOMAS M. VOSS, a free-lance writer, is the author of *Antique American Country Furniture: A Field Guide* (1978). He lives in Bucks County, Pennsylvania.

LITA SOLIS-COHEN covers the field of antiques for the *Philadelphia Inquirer*. Her column, distributed by the Artists and Writers Syndicate, reaches more than five million readers weekly. She is a graduate of Bryn Mawr College, and was a Winterthur Fellow. For nearly two decades she was staff lecturer at the Philadelphia Museum of Art and has taught courses in antiques and connoisseurship. Recently she became associate editor of *Maine Antique Digest*, to which she has been a regular contributor. The mother of two grown children, she and her husband, a Philadelphia lawyer, live in an old barn in Rydal, Pennsylvania.

Copyright ©1979 by Samuel Pennington, Thomas M. Voss and Lita Solis-Cohen • All rights reserved. Printed in the U.S.A. • No part of this publication may be reproduced or transmitted in any form or by any means, electronic or mechanical, including photocopy, recording or any information storage and retrieval system now known or to be invented, without permission in writing from the publisher, except by a reviewer who wishes to quote brief passages in connection with a review written for inclusion in a magazine, newspaper or broadcast. • For information contact: E.P. Dutton, 2 Park Avenue, New York, New York 10016 • Library of Congress Catalog Card Number: 78-74934 • ISBN: 0-525-05430-8 (Cloth) • 0-525-47571-0 (DP) • Published simultaneously in Canada by Clarke, Irwin & Company Limited, Toronto and Vancouver • 10 9 8 7 6 5 4 3 2 1 • First Edition

Contents

Introduction 7

Furniture 13

Pictures 147

Ceramics and Glass 169

Textiles 205

Metals 217

Specialty 233

The following is an alphabetical list of auction houses and auctioneers whose names appear in abbreviated form as the final entry in the captions in this book.

Bourne — *Richard A. Bourne Co., Inc.*
Hyannis, MA 02601

Brown — *Brown Brothers Gallery*
Route 413, Buckingham, PA 18912

Christie's — *Christie, Manson & Woods, Inc.*
502 Park Ave., New York, NY 10022

FACP — *The Fine Arts Company of Philadelphia*
John H. Frisk, Auctioneers
1611 Walnut St., Philadelphia, PA 19103

F.O. Bailey — *F.O. Bailey Co., Inc.*
141 Middle St., Portland, ME 04101

Freeman — *Samuel T. Freeman & Co.*
1808 Chestnut St., Philadelphia, PA 19103

Garth's — *Garth's Auctions, Inc.*
2690 Stratford Rd., Delaware, OH 43015

Julia — *James D. Julia*
Route 201, Skowhegan Rd., Fairfield, ME 04937

Kinzle — *Kinzle Auction Service*
Duncansville, PA 16635

Mooers — *Mooers and Neild*
R.F.D. 4, Gardiner, Maine 04345

Morrill — *Morrill's Auctions, Inc.*
Harrison, ME 04040

Morton's — *Morton's Auction Exchange*
643 Magazine St., New Orleans, LA 70190

Oliver — *Richard W. Oliver*
Rt. 35, R.F.D., Kennebunk, ME 04043

Pennypacker — *Pennypacker Auction Center*
1540 New Holland Rd., Kenhorst, Reading, PA 19607

Phillips — *Phillips*
867 Madison Ave., New York, NY 10021

Ralston — *Lloyd W. Ralston*
Fairfield, CT 06432

Roan — *Bob, Chuck and Rich Roan, Inc.*
Box 118, RD #3, Cogan Station, PA 17728

SPB — *Sotheby Parke Bernet, Inc.*
980 Madison Ave., New York, NY 10021

Skinner — *Robert W. Skinner, Inc.*
Route 117, Bolton, MA 01740

Sloan — *C.G. Sloan & Co.*
715 13th St. N.W., Washington, D.C. 20005

Theriault — *Auctions by Theriault*
Box 174, Waverly, PA 18471

Withington — *Richard W. Withington, Inc.*
Hillsboro, NH 03244

Most of the photographs reproduced in this book are copyright by the individual auction houses named in each caption.
All photographs from SPB are copyright Sotheby Parke Bernet, Inc., New York.

Some of the objects illustrated in this book have also appeared in other books, and that fact is noted in the captions. When one of those books is referred to in more than one caption, the reference is abbreviated to the author's last name and the figure number in his book. The following is a list of those books and authors.

Downs — Joseph Downs,
American Furniture: Queen Anne and Chippendale (1952)

Hornor — William Macpherson Hornor, Jr.,
Blue Book of Philadelphia Furniture (1935; reprinted 1977)

Kirk — John T. Kirk,
American Chairs: Queen Anne and Chippendale (1972)

Lockwood — Luke Vincent Lockwood,
Colonial Furniture in America (3rd ed. 1929; reprinted several times)

Luther — Clair Franklin Luther,
The Hadley Chest (1935)

Nutting — Wallace Nutting,
Furniture Treasury (1928; reprinted several times)

Sack — Albert Sack,
Fine Points of American Furniture—Early American (1950; reprinted several times)

Wiltshire — William E. Wiltshire,
Folk Pottery of the Shenandoah Valley (1975)

In addition, references to George S. and Helen McKearin's design groups of American glass are given as McKearin numbers, which may be found in their book *American Glass*.

Introduction

Americana at Auction '78 is the first single-volume anthology of items of Americana that were knocked down at a score of auction houses during a single calendar year.

The book was born because the authors suffer from what might be called the "Little Red Hen Complex." You recall the folktale: the Little Red Hen could find no one to help her sow the grain, or harvest the grain, or grind the grain into flour, or bake the flour into bread. And so at each step along the way she always said, "Then I shall do it myself." But when it came time to *eat* the bread, she was overwhelmed by volunteers.

Similarly, this book was undertaken because the authors always wanted to own it but could find no one who sold it. So we did it ourselves. Unlike the Little Red Hen, however, we invite you to help us "eat the bread."

What kind of book did we want? The same kind, we hope, that you would want: a book that would faithfully reflect the current market in Americana in virtually all its divergent styles and forms. "But," you may object, "auctions are but one peculiar part of the Americana market. Do they fill the bill?" Well, we will stipulate, as the lawyers like to say, that auctions can be jam-packed with mysterious subtleties, quirky twists of fate, emotional crosscurrents, and even instances of manipulative chicanery that defy scientific analysis. Perhaps you remember from general science that the test for the validity of an experiment is whether or not it can be repeated. Each auction is an experiment, too, but one that can never be repeated. That, however, is what makes auctions intriguing rather than humdrum. For better or worse, we feel that auctions do reflect the market in Americana because, in a very real sense, auctions are the market*place*. As auctioneer Robert W. Skinner has recently pointed out, auctions have increased "in frequency and popularity to the point where they now command more attention than any other aspect of the fine arts business. Auctions are the medium between seller and dealer/collector; prices realized at auction are the standard by which other, private transactions are judged."

Not only do auctions reflect the Americana market they also reveal a great deal about how buyers and sellers *feel* about the market. Auctions publicly, even shamelessly, proclaim which pieces are being embraced, and which shunned; which are accelerating, or decelerating, or just spinning their wheels; which are good, better or best.

Put another way, each time a piece becomes a candidate for the auction block, buyers are, in effect, asked to vote on its quality, condition, desirability, rarity, resale or investment potential, and any of the ten or a hundred other factors that collectively influence their opinion of it. Unlike a conventional election, however, in which each person has one vote, auctions are not democratic: each person has as many votes as he or she can muster, and each vote, you might say, is represented by a small, green paper ballot adorned with an engraving of George Washington on one side and the phrase "In God We Trust" on the other.

Put still another way, auctions speak louder than words.

We also wanted a book that would be useful, not only because it provided instant access to prices paid for a variety of objects (each one of which is illustrated) at a variety of auction houses, but also because those illustrations would themselves have an intrinsic value. We wanted a book that would be a systematic panoply of the best, or most interesting, or most honest, or most funky, or most beautiful, or most sought-after pieces of Americana sold during a single year. In short, a book that would last, that could be used and reused without becoming stale. And beyond that, a book that most people could afford.

Whether all those standards have been met is for the reader to judge. Suffice it to say that when work actually began, we found ourselves in terra incognita. No book quite like this one had ever been undertaken; there were no precedents; there was no other book whose lead we could follow. So we followed our own instincts, judgment, and combined experience as professional "Americana watchers" and writers—and we argued a lot—and *Americana at Auction* is the result.

You may applaud or hoot our editorial methods, but in any case we feel that you should be aware of what they are. First, we decided to limit the book to objects sold during calendar 1978. This is, we know, an arbitrary division that does not conform to the traditional New York

auction season, which begins in the fall of each year and ends as summer of the following year approaches. But auctions are now a year-round way of life in much of the rest of the country, and focusing on just one year at a time has a certain neatness to it. Second, we decided to omit American academic paintings and books, which are adequately covered in other publications. And third, we decided to include no objects that, to our knowledge, had any serious flaws or were in any way questionable or controversial. In a few cases we have made some concessions to rarity, but then we have tried to describe any flaws and/or restorations. Those decisions have obviously limited the types of objects included here, but they had the advantage of providing a framework within which we could work comfortably and that could be used in the future.

Early on we concluded that to use such terms as *Pilgrim, William and Mary, Queen Anne, Chippendale, Hepplewhite, Sheraton, Federal, Empire* or *Victorian* when describing furniture would serve no purpose. We have nothing against those terms; however, using them would have added nothing to a book like this, given its organization and the fact that we have made every effort to provide approximate dates for each object. Furthermore, such terminology would have led to the sort of confusion often encountered in the captions in auction catalogs, where the writer has had to decide such irrelevant questions as "Is it Queen Anne, or Chippendale, or transitional?" when the piece in question was not made during Queen Anne's reign nor copied from an engraving in Chippendale's design book in the first place. Finally, as you read through *Americana at Auction* you should see that, even when it was possible to name the style of a given piece, the style itself bears little or no consistent relationship to the piece's aesthetic or monetary value.

Among all the possible methods of organization we chose simply to arrange comparable objects in ascending order of price. This method, as you will see, holds many surprises, especially in the middle-price ranges. For example, it becomes immediately apparent that high-style, urban objects do not always bring prices as high as their less sophisticated country cousins. On the other hand, examples of sublime design—that is, the best—inevitably outpace other objects, at least as far as the purse, wallet or joint checking account is concerned.

Is this book, then, a price guide? Yes and no. In that it reports the price someone was willing to pay for a particular item of Americana, it is obviously a guide to that price. But an auction price establishes the worth of an item only at the split second when the auctioneer's hammer falls. Five minutes later, or today, the same piece might bring more, or less, or the same, and there is only one way to find out: by reauctioning it.

Are the prices in *Americana at Auction* wholesale or retail prices? That is also a touchy question that defies an easy answer, but we'll try to answer it anyway. Since auctions are generally regarded as the wholesale marketplace for antiques, and since at least a simple majority of the pieces in this book were purchased by dealers—presumably either for resale or on a commission basis for their customers—a fair assumption would be that the majority of prices listed here are wholesale. For that and other reasons we have indicated in as many captions as possible who the buyer of an object was: a dealer (probably a wholesale purchaser), or a private collector or an institution (probably retail purchasers). But if a dealer purchased an object, how would you determine its retail price? That question is even more difficult to answer. Dealer markups, in our experience, can range from as little as 10 percent (for a quick sale) up to 1,000 percent or even more. Furthermore, an object may be sold and resold among many dealers before, as they say in the antiques business, there is no more "room left in it" and it "goes retail." So the first dealer's markup may have little relationship to the cumulative markup at the end of the selling chain.

But the above are merely rules of thumb, and as every amateur carpenter knows, thumbs sometimes get in the way of hammers (even auctioneers' hammers). For one thing, dealers have been known to make mistakes, to

overestimate the resale potential of a piece and "overpay" for it at auction; thus a supposedly "wholesale" auction price may be "distorted" by a dealer's bad judgment. Or suppose a dealer owned a certain chair and found the identical mate to it in an auction—not an unheard-of situation. Knowing that a pair of chairs can usually be sold for far more than twice what a single chair would bring, the dealer might appear to "overpay" for the single chair. The list of examples could continue, but now it's time to get on to other matters.

1978: A Brief Review

The year 1978 was not notable for any landmark auctions, such as the Howard Reifsnyder sale at the American Art Association in April of 1929, when $44,000 was paid for a Philadelphia highboy, other price peaks were reached that would not be reached again for years to come, and *The New York Times* was prompted to opine that American antiques were valuable; or the Reginald M. Lewis sale at Parke-Bernet in 1961, when Colonial furniture began an upward spiral; or the Landsell K. Christie sale at Sotheby Parke Bernet (SPB) in 1972, when prices climbed to even greater heights. Nor was there a sale to match that held in the winter of 1977 at SPB, when the Mary Blackwell Moore collection made record prices.

Instead, 1978 was marked by a number of multiowner sales. Several of these included well-known collections, for example, the Wiltshire collection of American folk pottery sold at SPB and the Sussel collection of American naval items sold at C.G. Sloan. There were several important house sales, including the Marvin sale held by SPB in Vermont.

Nonetheless, many record prices were made during 1978: for a single piece of American furniture (**fig. 287**), for a pair of American chairs (**fig. 35**), for a piece of miniature furniture (**fig. 350**), for a spice chest (**fig. 256**), for a Connecticut highboy (**fig. 250**), for a Belter-type parlor suite (**fig. 72**), for American pottery—both redware (**fig. 457**) and stoneware (**fig. 540**)—for American pewter (**fig. 646**), a silver teapot (**fig. 635**) a folk watercolor (**fig. 398**), a Jacquard coverlet (**fig. 585**), a needlework picture (**fig. 604**), and for an English transfer-printed historical jug made for the American market (**fig. 580**). Such world-record prices warm the hearts of auction house press agents, but, like the proliferation of records in the *Guinness Book of Records*, a world-record price can be set merely by defining a new category. Nevertheless, record prices do provide a yardstick not only for measuring the top of the present market but also for comparing the present with the past, and possibly even for gauging the future.

Interestingly, a few records were also missed. For instance, an Amelung glass tumbler engraved with the seal of the United States, offered during a morning session at SPB in February, did not make its reserve price and was bought in at $30,000, which would have been a record for American glass had the piece actually been sold. Minutes after the sale, it was sold privately to a collector who thought the tumbler was going on the block in the afternoon and had missed the morning session. Unfortunately, we cannot know the outcome of those private negotiations.

During 1978 most auction houses experienced an increase both in gross dollar sales and in the number of lots sold, but the former far outpaced the latter. For example, William W. Stahl's Department of American Decorative Arts and Furniture at SPB reported less than a 1 percent increase in the number of lots sold but a 13 percent increase in gross dollar sales. To achieve these levels, auction houses competed for buyers, who seemed to flock to all of them with ready cash. But they also competed for sellers. Notably, the English firm of Christie's in New York maintained its system of "ten-and-ten," in which a modest standard commission rate of 10 percent of the hammer price is charged to the seller, with an additional 10 percent "premium" surcharged to the buyer and payable to the house. Christie's attracted so many quality consignments with this system that, beginning in 1979, it has been adopted by their archrival in New York, SPB, as well as by others.

The influx of consignments was also due in part to the right people needing cash, or divorcing, or moving to smaller quarters, or moving out of this world completely. In addition, the extensive publicity of high auction prices flushed some extraordinary items out of collections and attics that otherwise would probably not have appeared on the market. That, in turn, caused dealers who prefer to buy privately to buy publicly, forcing them to do battle with collectors as well as other dealers.

This produced such prices as the $160,000 ($176,000, with buyer's surcharge) paid at Christie's for a pair of Philadelphia side chairs **(fig. 35)**, which are similar to a pair sold at SPB in 1977 for $140,000. These are of a type known as "Reifsnyder" chairs because they are similar to single chairs that sold for $6,000 and $9,000 at the Reifsnyder sale a few months before the stock market crashed. It is worth noting that as late as 1950 a chair of this type was knocked down at the Norvin H. Green sale at Parke-Bernet for only $6,500. (However, as we mentioned above, when it comes to chairs the formula is often 1+1=3, pairs of chairs bringing far more than twice what a single chair would bring.)

Christie's, at least for the moment, also holds the current record for a single piece of American furniture: a block-and-shell carved kneehole desk attributed to the Goddard-Townsend workshop in Newport, Rhode Island **(fig. 287)**. Knocked down in October for $140,000 ($154,000 with buyer's surcharge), it displaces a Massachusetts bombe' serpentine chest of drawers that sold at SPB in 1977 for a then record $135,000. A similar Newport kneehole desk brought $120,000 at the Landsell K. Christie sale at SPB in 1972; but taking inflation into account, the new record is not a remarkable gain and, even using the total of the hammer price plus buyer's surcharge ($154,000), it represents an increase of only 4.25 percent compounded annually. In 1971, one of these desks sold for $104,000 at Samuel T. Freeman in Philadelphia, but back in 1950 at the Norvin H. Green sale, another sold for $16,000—the highest price of that sale and more than double the $7,000 another had brought in the Andrew M. Williams sale at Parke-Bernet in 1948. Still another had sold at the Wallace Nutting sale in 1941 for $6,300.

Several exceptional pieces of miniature and small scale furniture were sold during 1978, and the price histories of their forms are interesting. In 1944 a miniature slant-lid desk sold at the Mrs. J. Amory Haskell sale at Parke-Bernet for $170, but by 1972 an example in tiger maple could command $13,500 at the Landsell K. Christie sale at SPB. By 1978 buyers were apparently even more convinced that small is beautiful, for in March, at the sale of a small estate held in an American Legion hall in Gardiner, Maine, auctioneers Mooers and Neild knocked down an early eighteenth-century walnut and maple child's desk with ball feet for $17,000 **(fig. 351)**. (It doesn't seem to matter where a piece is sold as long as the word gets out and at least two enthusiastic, well-heeled buyers are present.) Some claimed that the ball-foot desk had made a new record for miniature furniture, arguing that the so-called miniature highboy that had sold in 1972 for $18,500 at the Landsell K. Christie sale was in fact a spice chest—not a piece of miniature furniture—since its upper case had cupboard doors enclosing five tiers of small drawers. However, by April of 1978 the argument had become academic, for the record for miniature furniture was incontestably shattered when a flat-top Philadelphia highboy sold at SPB for $65,000 **(fig. 350)**. Then, in November, the spice chest record was itself broken when a Philadelphia example made $74,000 **(fig. 256)** also at SPB.

Market Trends

The fact that no two antiques are exactly alike makes it difficult to compare them and thus graph market trends. In spite of that we'll still try to make some generalizations.

Certain furniture forms continued to appreciate in value in 1978. For example, four-drawer Pennsylvania chests with quarter-columns—whose prices generally increase as their widths decrease—appeared to reach a new price level. At the Arthur J. Sussel sale at Parke-

Bernet in 1959, a fine walnut chest of this type, 37½ inches wide, sold for $425. In 1973 a walnut example, 41 inches wide, sold for $1,900, and another, 42 inches wide, sold in 1974 for $1,600, both at SPB. In 1977 a mahogany example, 38½ inches wide brought $7,500, while in 1978 a chest only 36 inches wide made $8,750 **(fig. 221)**.

Quarter-column chests with a slightly different drawer arrangement—two narrow drawers over three full-width ones—generally bring a premium. In 1967 one sold at SPB for $4,000, while in 1978 a similar mahogany example associated with the Powel family of Philadelphia brought $18,000 at C.G. Sloan **(fig. 226)**.

No comb-back Windsor chair sold in 1978 was a fine as the one in the Moore sale in 1977 that brought $10,000. However, continuous-arm and other Windsor chairs were numerous and showed dramatic appreciation. In 1944 a pair of continuous-arm chairs sold at the Haskell sale for only $240. A similar pair attributed to Ebenezer Tracy sold to a dealer in 1975 for $1,600. In 1978 a single continuous-arm chair branded by Tracy brought $2,500 at a Robert W. Skinner auction **(fig. 82)**, and another example, refinished and without a brand, was sold by SPB at the Robert Gruen house sale for $2,200 **(fig. 85)**. A pair with old paint over older paint fetched $4,200 at Garth's **(fig. 91)**.

Appreciation in other categories was often no less dramatic. The Peter van Dyke silver tea pot **(fig. 635)**, which sold to a dealer for $47,000 after two collectors had bid it up to $46,000, was almost identical to another pear-shaped example by Adrian Bancker that brought $2,000 at the Norvin H. Green sale in 1950. However, a pewter tankard by Henry Will **(fig. 646)**, which sold for a record $8,250, showed a small advance over the $7,750 paid for a William Will tankard at the Moore sale in 1977. In 1973 a flat-top tankard by William Will sold for $5,600. Twenty-five years ago, any of these tankards would probably have brought less than $1,000.

In the area of folk pottery a tulip-decorated sgraffito plate brought $5,750 **(fig. 474)**. Its diameter was two inches less than that of a similar plate that brought only $160 at the George Horrace Lorimer sale at Parke-Bernet in 1944.

But not all pieces have appreciated. You will note that certain *identical* lots actually sold for less in 1978 than in previous years (we've noted this fact in the captions whenever possible). Perhaps this validates an old antiques-world adage that a piece will never bring as much the second time around until at least seven years have passed. That may be another way of saying that auction buyers are hungry for "fresh" merchandise—objects that have been off the market for a tantalizingly long time. Auction buyers are a suspicious crew, and nothing seems to arouse their suspicions more than a piece that comes on the block only a year or so after it was previously sold, or a piece that has knocked around the dealers' circuit for a year or two unsold and suddenly appears at auction. Even if there is nothing wrong with the piece, buyers can afford to ignore it because so much else is available.

On the other hand, some pieces illustrated here will probably never again be sold at auction—for example, the marvelously idiosyncratic walnut and cherry secretary made by John Shearer in Martinsburg, West Virginia, in 1801 **(fig. 302)**, purchased by the Museum of Early Southern Decorative Arts for $40,000 at SPB. But, undoubtedly, there are more pieces that will return to the block in future years than those that won't. One of our objectives is to chart the courses of those returning pieces—as well as of the Americana market as a whole—through future volumes of this book. And with your support, there will be future volumes.

No project of this sort could succeed without the cooperation of those who are involved in the day-to-day business of auctioning Americana. To thank each individual at each auction house for his or her help would rob this book of valuable space that we would prefer to devote to illustrations and captions. Therefore, we hereby thank you all—from the largest auction house to the smallest—and hope you approve of the fate of the materials and information that you were kind enough to permit us to use.

Captions

The captions in this book are arranged in the following format:
Figure number. Description of object / **hammer price** (in boldface) / estimated price / purchaser (dealer, private or institution) / other relevant information about provenance, exhibits, and the like / date of sale during 1978, and auction house or auctioneer.

Although all captions do not contain all of the above information, a "complete" caption would appear as follows:

242. Highboy, tiger maple, refinished, original brasses, two backboards replaced, probably R.I., 1755-95 / **$9,500** / provenance: Samaha Antiques, Ohio / 5-5 Garth's.

(Note: During 1978, Christie's, New York, added a 10 percent buyer's surcharge to the hammer price of each lot sold. For the convenience of the reader, the sum of the hammer price *plus* the 10 percent surcharge appears in parentheses after the hammer price for each Christie's lot.)

Abbreviations

The following abbreviations are used in the captions in this book.
c. — century
dia. — diameter
dwts. — pennyweights
est. — preauction estimated price
ex-coll. — from, or formerly in, the collection of
h. — height in inches
l. — length in inches
o.p. — original paint
ozs. — ounces (weight)
p.r. — paint restored
w. — width in inches

(Note: Dimension abbreviations are used only in certain cases for the sake of clarity. Most dimensions are given as the horizontal by the vertical measurement in inches, and no abbreviations are used.)

The authors have made every effort to be completely accurate in this book. No one, however, is perfect. Therefore, no warranty is made or implied as to the authenticity, condition, or value of the pieces illustrated and described herein.

Furniture

Seating Furniture 14
Tables, Stands, Sideboards, Serving Tables 52
Chests ... 81
Chests of Drawers and Tall Chests of Drawers 87
Highboys, Lowboys, Chests on Chests 95
Desks and Secretaries 108
Cupboards .. 122
Beds ... 129
Clocks ... 132
Boxes, etc. (Hanging Things, Miniature Furniture and
 Miscellaneous) 138
Mirrors .. 144

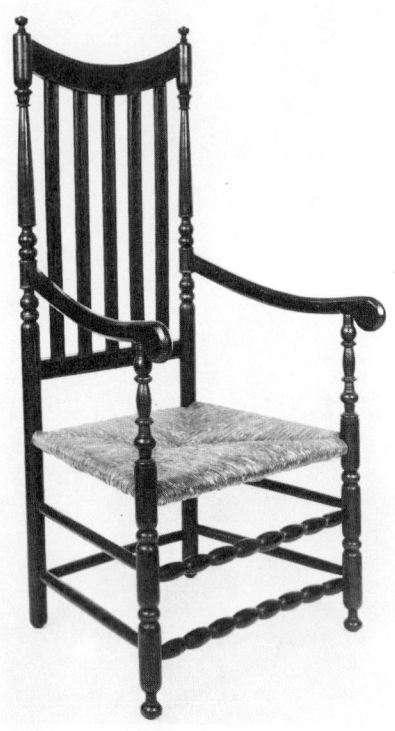

1. Armchair, maple painted black with yellow striping, probably Conn., 1710-50 / **$950** / est. $1,200-1,500 / 9-30 SPB.

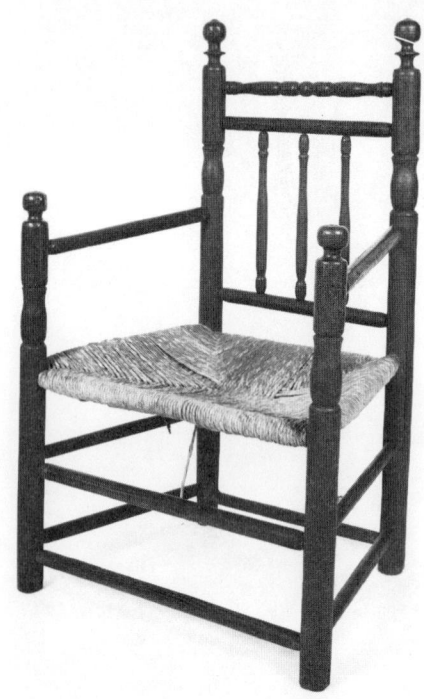

2. Armchair, ash and oak, New England, 1670-1710 / **$3,000** / est. $2,000-2,500 / dealer / provenance: Harry Arons, Antiques, Ansonia, Conn. / 9-30 SPB.

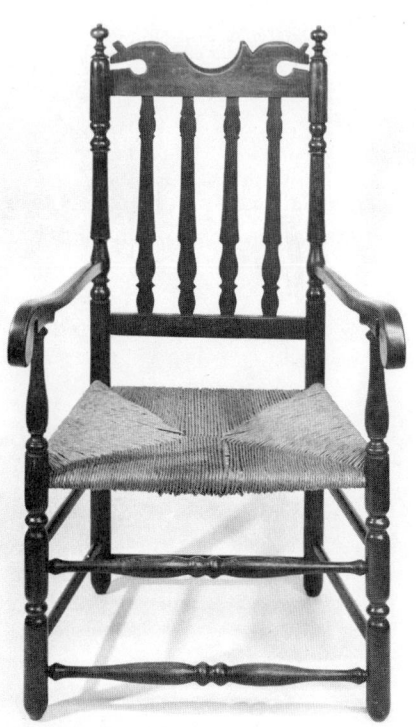

3. Armchair, Mass. or N.H., 1750-1800 / **$400** / 1-31 Phillips.

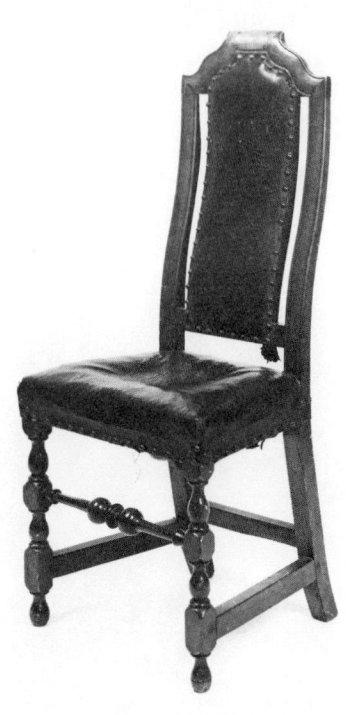

4. Side chair, maple, crest rail has silver plaque inscribed "This chair belonged to William Williams, a signer of the Declaration of Independence, 1776," probably Boston, circa 1730 / **$3,500** / est. $2,000-3,000 / 11-18 SPB.

Furniture

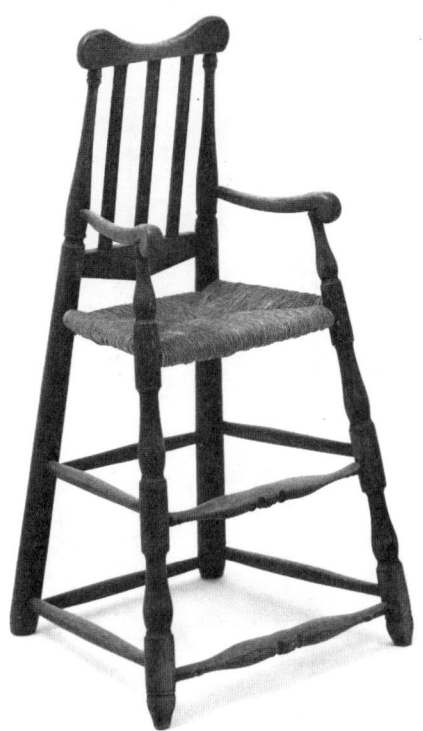

5. High chair, worn red paint, probably Conn., 1740-1800 / **$2,050** / 7-7 Withington.

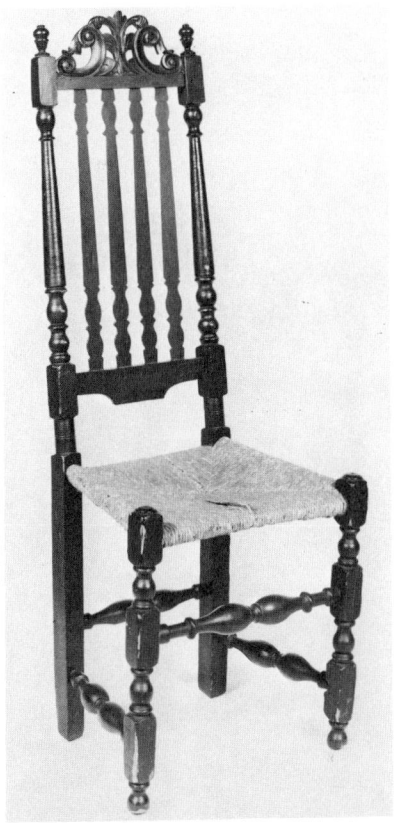

6. Side chair, painted black, Mass., 1700-35 / **$2,750** / est. $1,000-1,500 / dealer / 4-29 SPB.

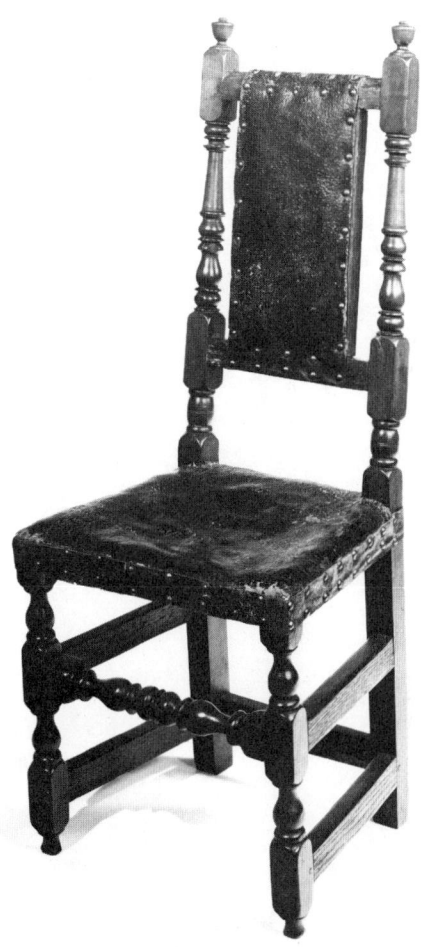

7. Side chair, maple and oak, possibly Boston, 1690-1735 / **$2,400** / est. $2,500-3,500 / dealer / 2-4 SPB.

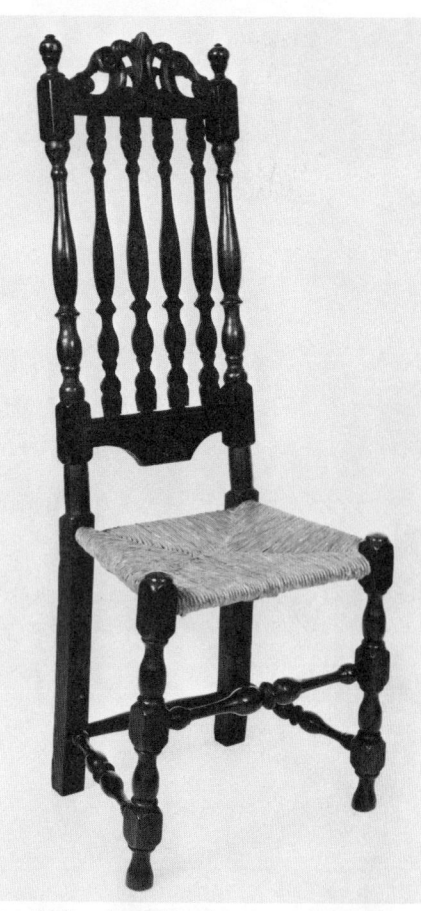

8. Side chair, red grain-painted on black, eastern Mass., possibly Boston, 1700-35 / **$4,250** / est. $1,500-2,500 / dealer / 9-30 SPB.

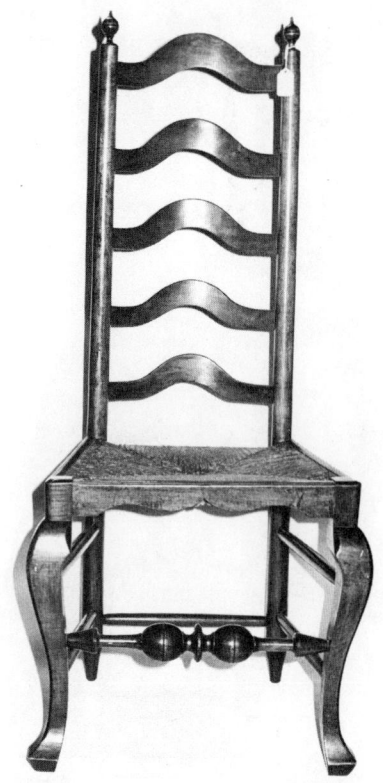

9. Side chair, maple, attributed to William Savery, Philadelphia, circa 1750 / **$3,200** / dealer / 6-24 Morrill.

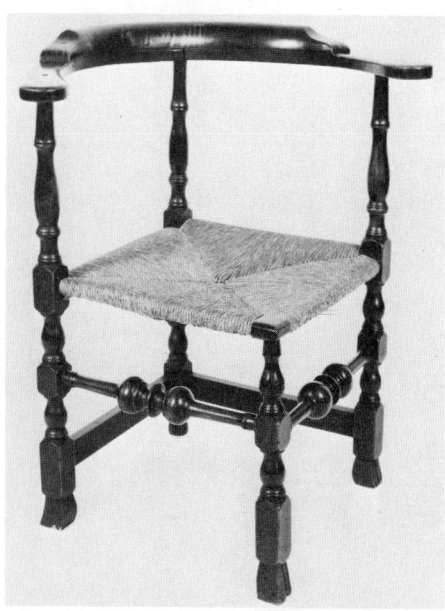

10. Corner chair, maple, probably Mass. or Conn. Valley, circa 1750 / **$7,250** / est. $1,500-2,000 / private / provenance: Harry Arons, Antiques, Ansonia, Conn. / 9-30 SPB.

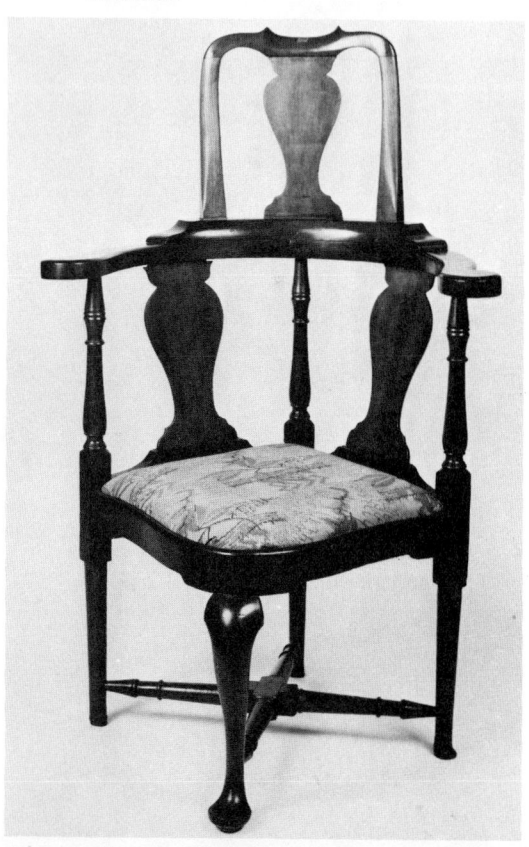

11. Corner chair, cherry, R.I., 1740-50 / **$5,000** / est. $15,000-20,000 / dealer / 2-4 SPB.

Furniture

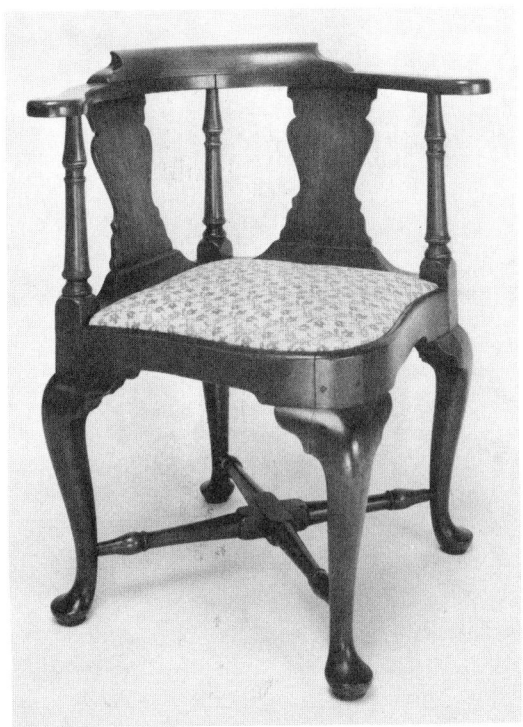

12. Corner chair, cherry, mid-18th c., / **$8,500** / 10-30 Pennypacker.

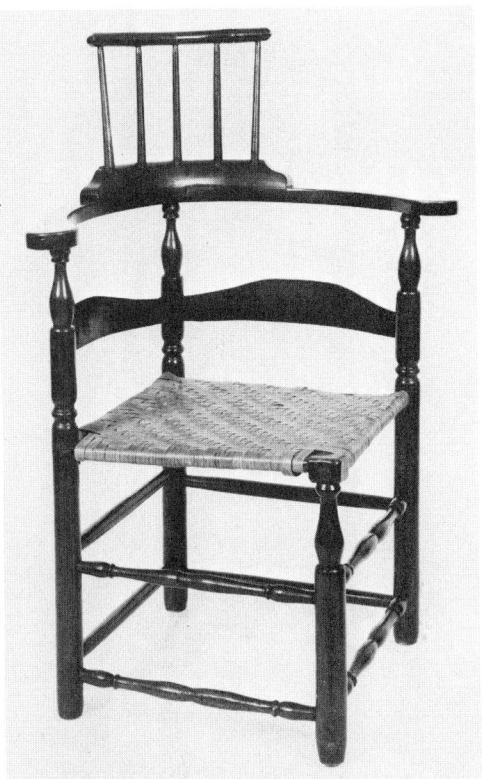

13. Corner chair, maple, New England, circa 1750 / **$2,900** / est. $1,500-2,000 / 9-30 SPB.

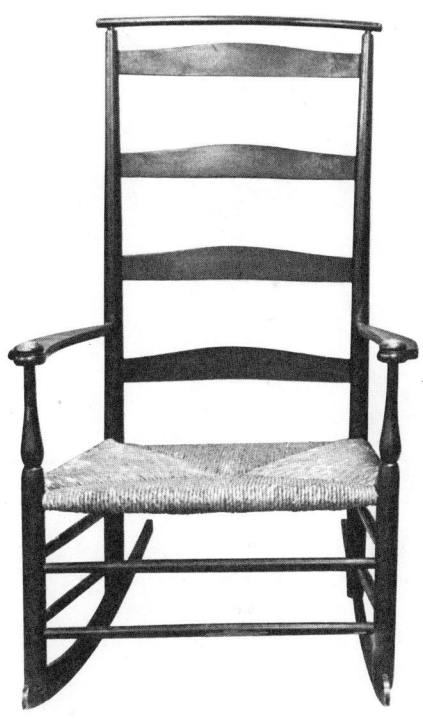

14. Rocking chair, original finish and decal reading "Shaker's, No. 7, Trade Mark, Mt. Lebanon, N.Y." 1835-early 20th c. / **$410** / 4-7 Garth's.

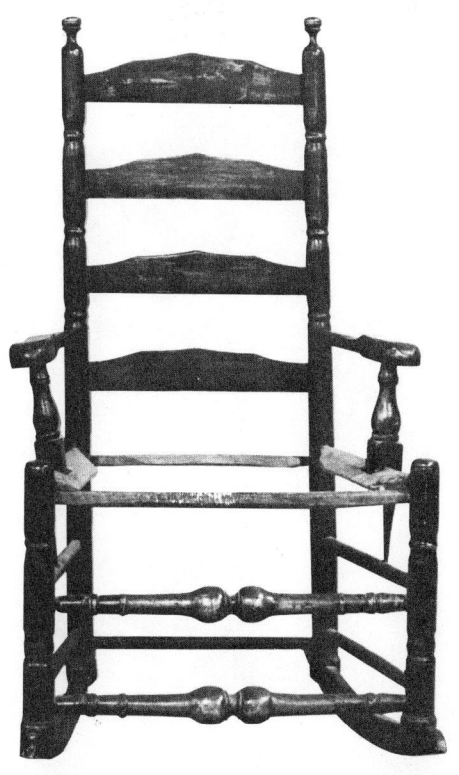

15. Rocking chair, old worn black paint shows red beneath, probably Conn., late 18th c. / **$290** / 9-22 Garth's.

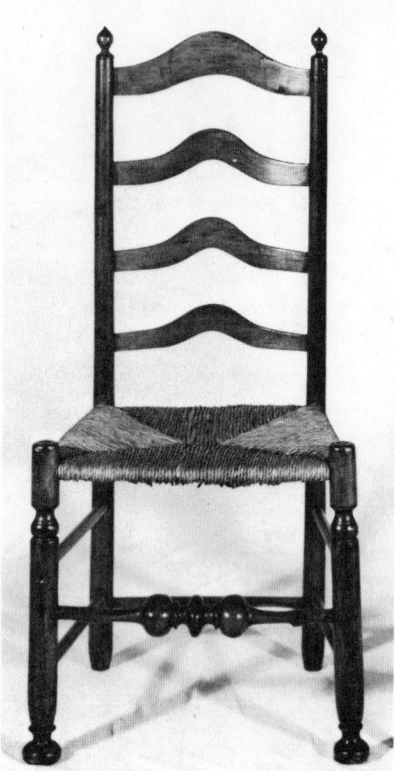

16. Side chair, refinished, Delaware Valley, 1750-1810 / $500 / dealer / 9-27 Brown.

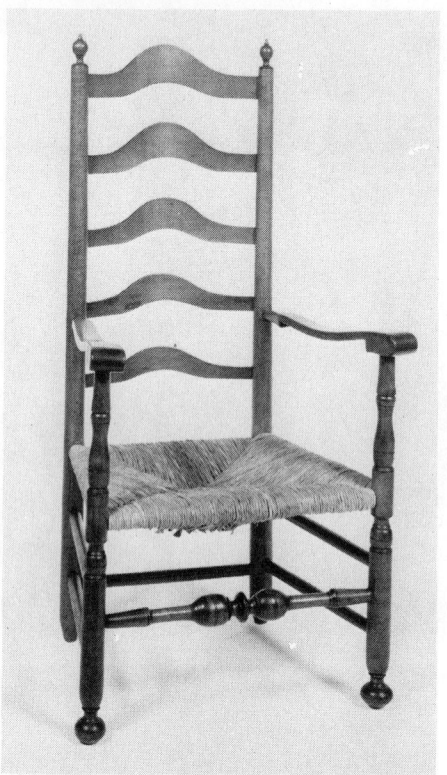

17. Armchair, maple, Penn., 1730-40 / $2,500 / est. $2,000-2,500 / provenance: Israel Sack, Inc., N.Y. / 2-4 SPB.

18. Set of six side chairs, traces of brown paint with yellow striping, Delaware Valley, 1750-1810 / **$18,000** / est. $10,000-12,000 / dealer / provenance: David Stockwell, Inc., Wilmington, Del. / 2-4 SPB.

Furniture

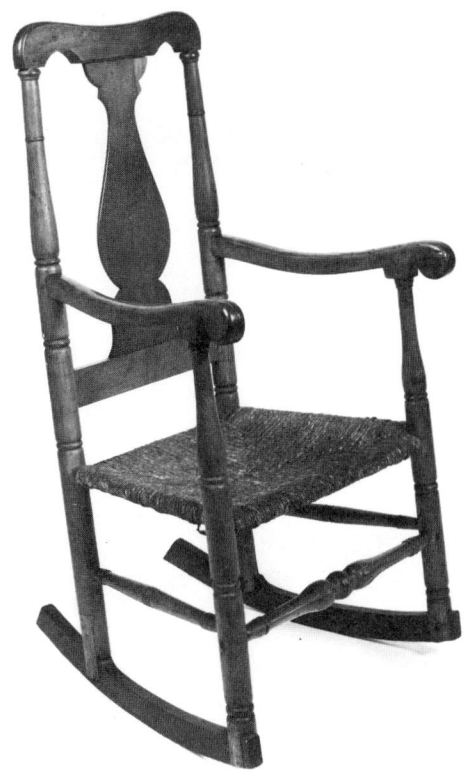

19. Armchair, rockers added, splat patched at top right, attributed to the Dominy workshop, Long Island, circa 1780 / **$500** / est. $500-700 / 9-9 SPB.

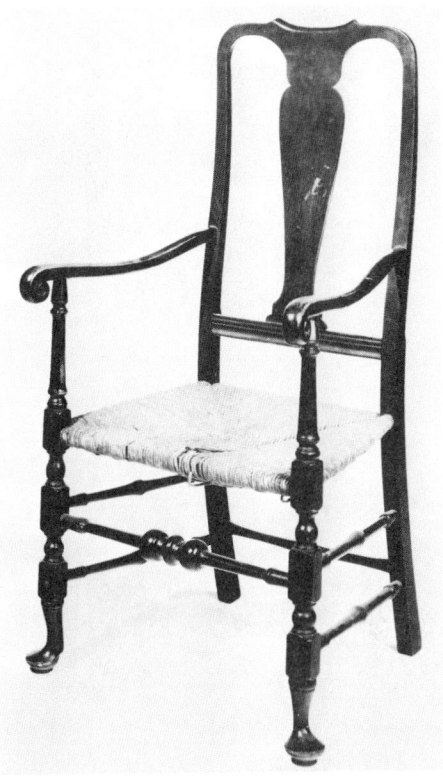

20. Armchair, Conn. Valley, 1740-60/ **$1,700** / est. $2,000-2,500 / 2-4 SPB.

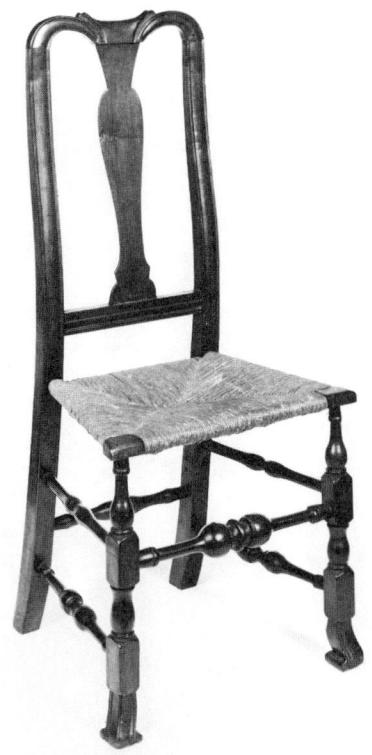

21. Side chair, cherry, Mass., 1740-60 / **$600** / est. $600-800 / 4-29 SPB.

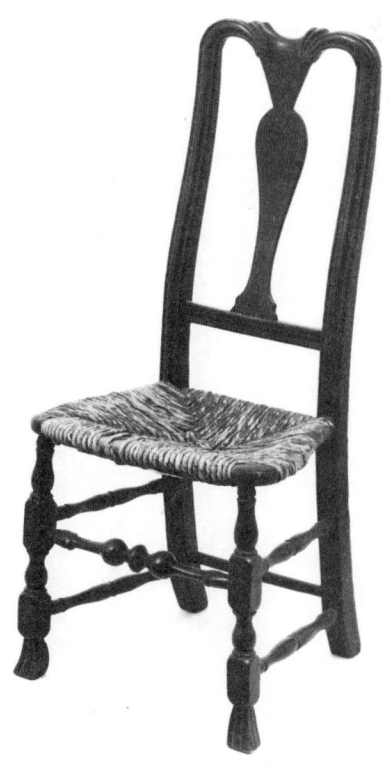

22. Side chair, old brown paint, New England, 1740-60 / **$1,800** / 7-7 Withington.

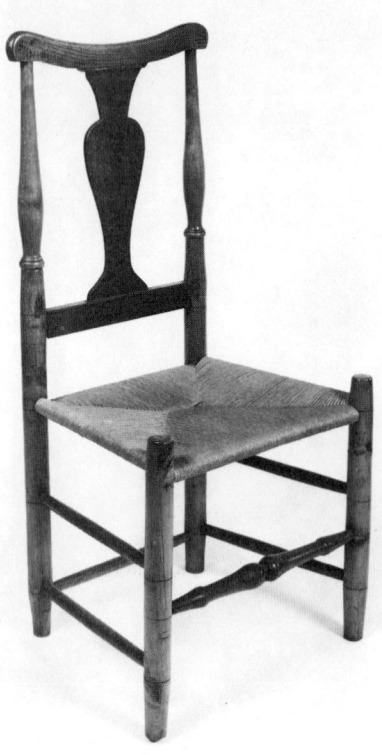

23. Side chair, attributed to the Dominy workshop, Long Island, late 18th c. / **$400** / est. $300-500 / provenance: William Hedges, East Hampton, N.Y. / 9-9 SPB.

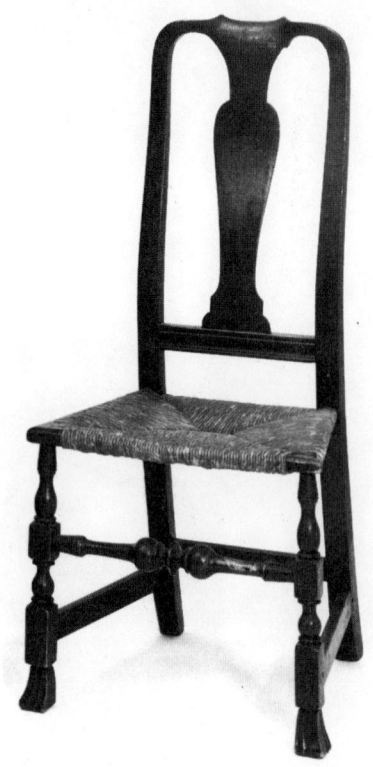

24. Side chair, old red finish, New England, 1740-60 / **$1,300** / 7-7 Withington.

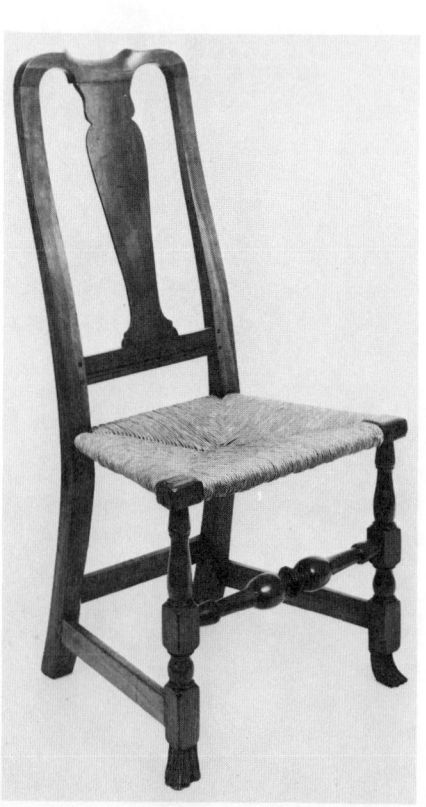

25. Side chair, cherry, New England, 1740-60 / **$850** / est. $300-500 / private / 9-30 SPB.

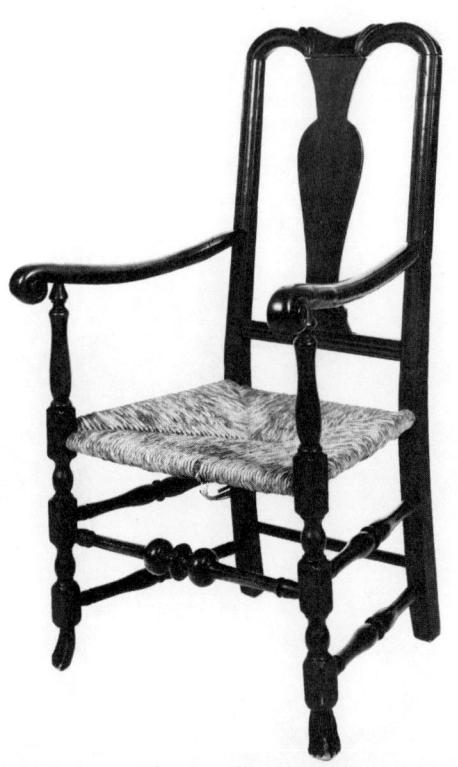

26. Armchair, maple, painted black-brown, Mass., 1740-60 / **$2,400** / est. $1,500-2,500 / dealer / 9-30 SPB.

Furniture

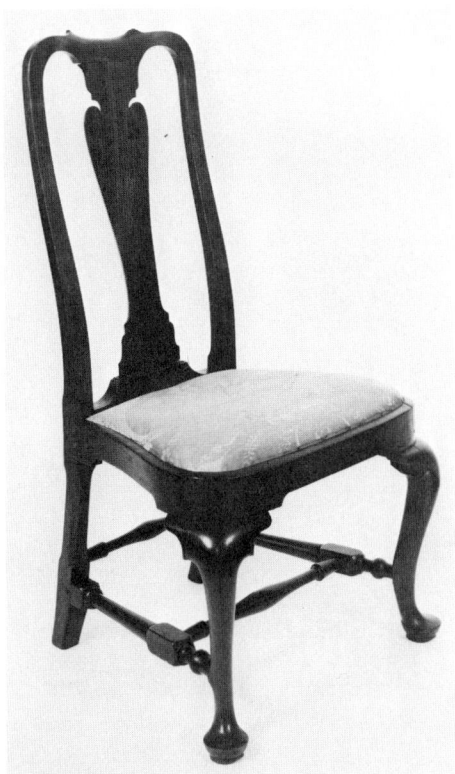

27. Side chair, walnut, R.I. or Mass., 1740-60 / **$4,500** / est. $2,000-2,500 / 9-30 SPB.

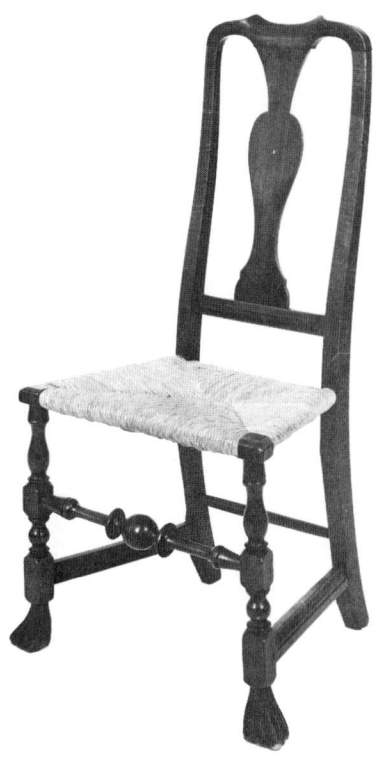

28. Side chair, tiger maple, probably Mass., 1740-60 / **$5,500** / est. $700-900 / dealer / 9-30 SPB.

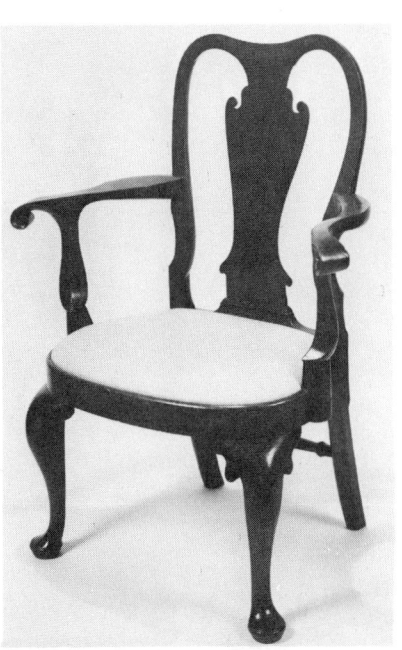

29. Armchair, walnut, attributed to William Savery, Philadelphia, circa 1740 / **$40,000** / est. $25,000-35,000 / dealer / provenance: coll. Louis Guerineau, N.Y., and Israel Sack, Inc., N.Y.; exhibited Metropolitan Museum of Art, 1925-71; illus. and discussed in Kirk / 2-4 SPB.

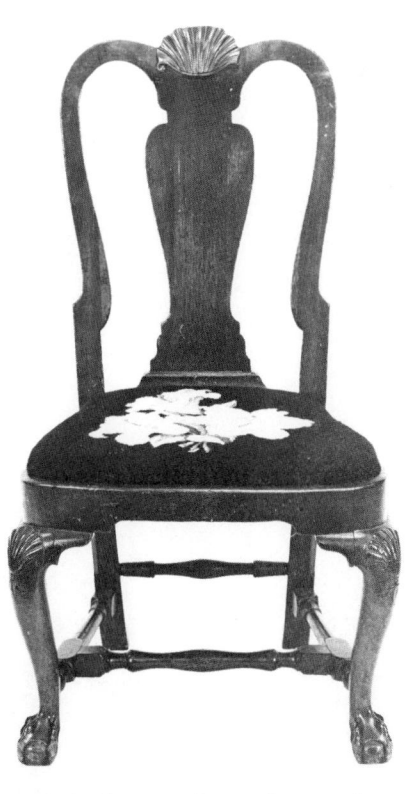

30. Side chair, walnut, chair and seat frame marked "VII," Newport, R.I., 1740-60 / **$9,000** / est. $10,000-12,000 / 9-22 Skinner.

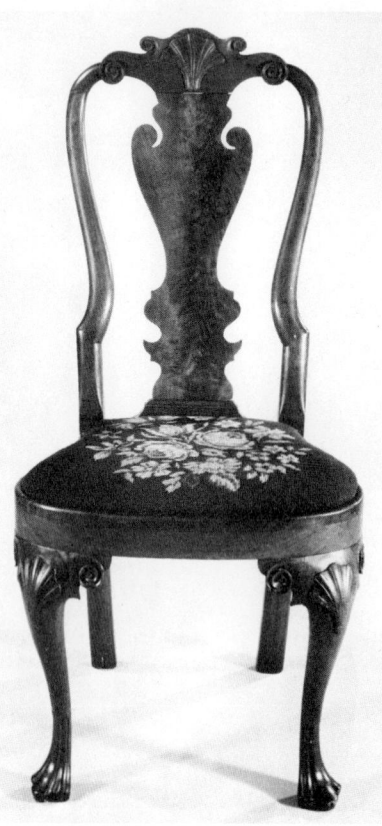

31. Side chair, walnut, crest rail repaired with iron braces, Philadelphia, 1740-60 / **$8,700** / 3-13 Freeman.

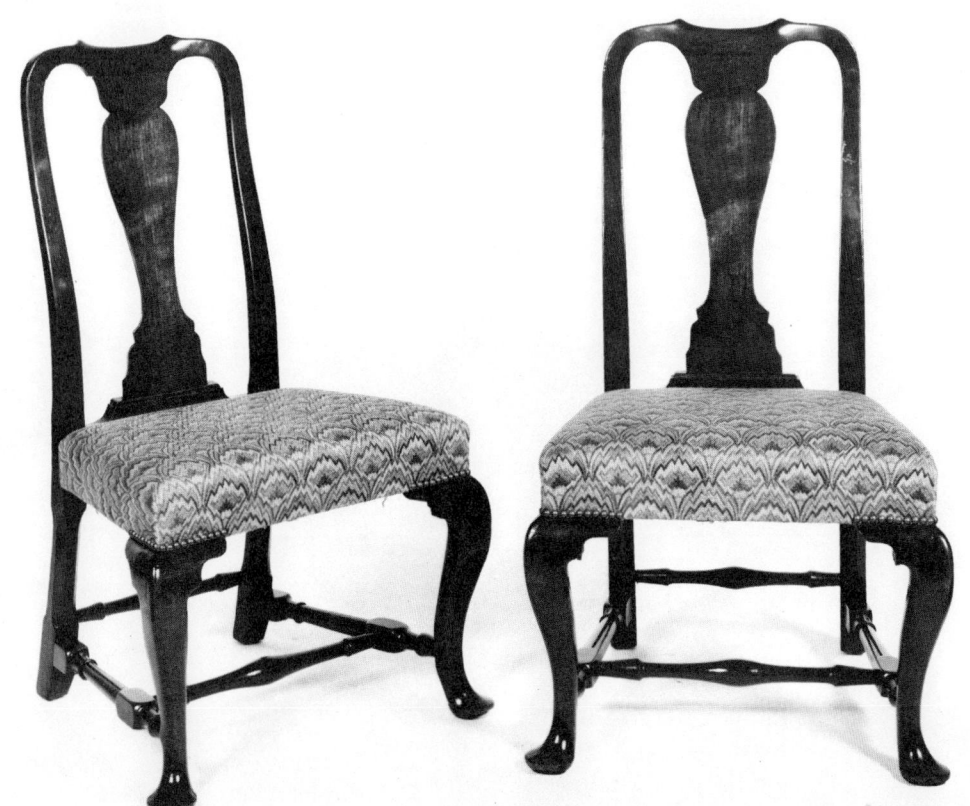

32. Pair of side chairs, walnut, Mass., 1740-60 / **$4,250** / est. $4,000-6,000 / dealer / 4-29 SPB.

Furniture

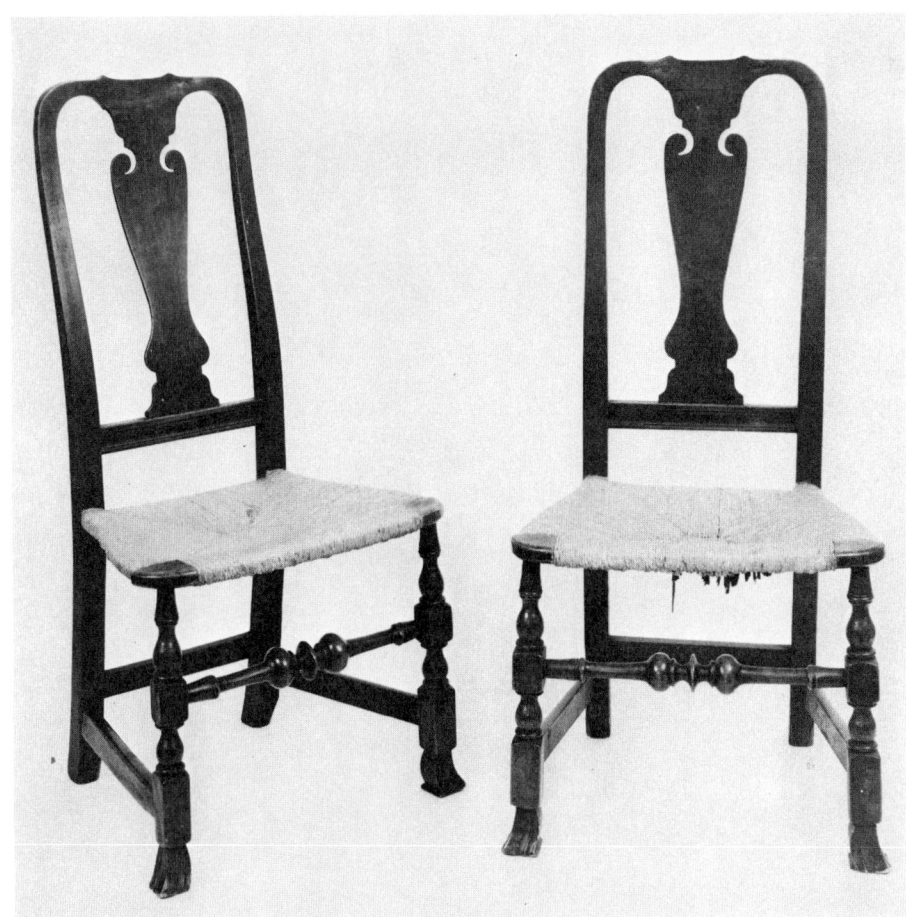

33. Pair of side chairs, tiger maple, Mass., probably Salem, 1740-60 / **$9,000** / est. $4,000-6,000 / provenance: Harry Arons, Antiques, Ansonia, Conn. / 9-30 SPB.

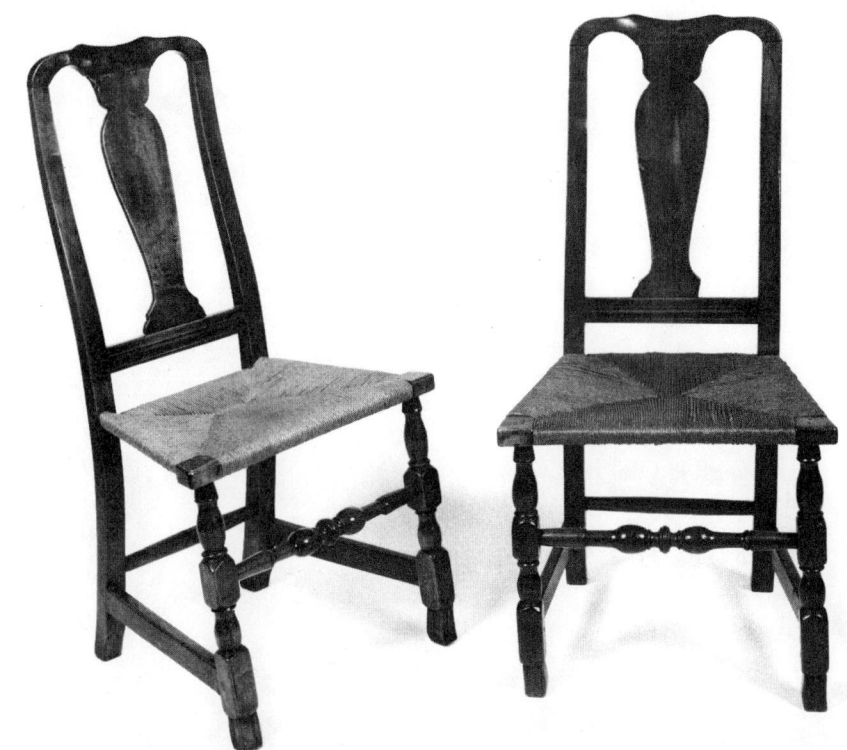

34. Assembled pair of side chairs, one splat broken at bottom, probably New England, 1740-60 / **$475** / est. $400-600 / 9-9 SPB.

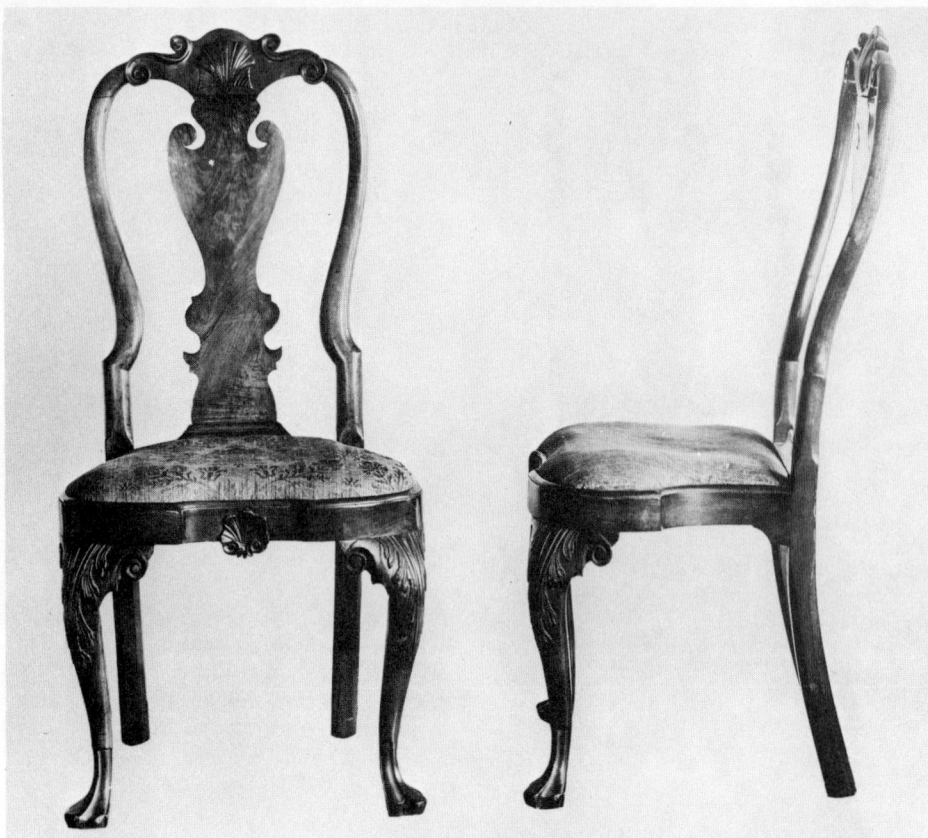

35. Pair of side chairs, walnut, Philadelphia, 1740-60 / **$160,000** ($176,000) (record for pair of chairs) / est. $60,000-80,000 / dealer / provenance: the Coates family, Philadelphia and New York; pair of chairs from this set in Williamsburg; illus. in Hornor, no. 82 and in Kirk, no. 56 / 10-21 Christie's.

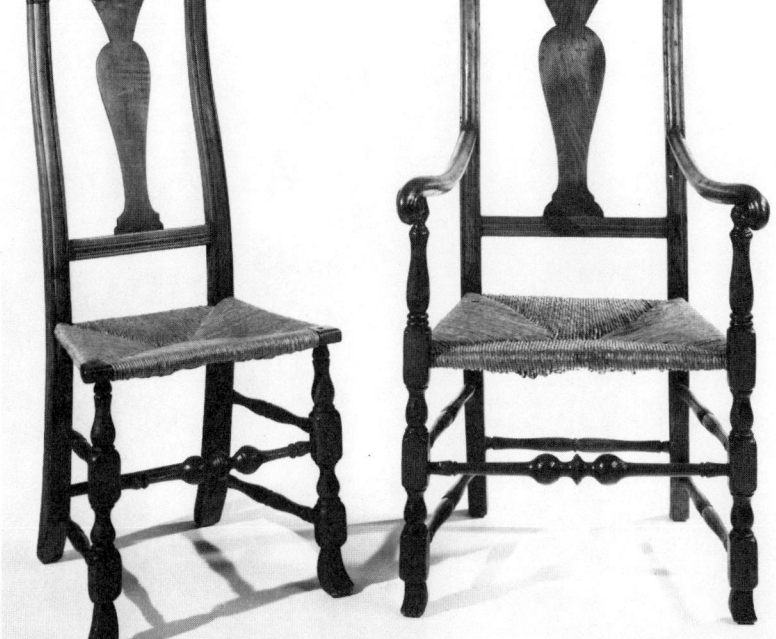

36. Assembled set of two armchairs and eight side chairs (two shown), Conn., 1740-60 / **$11,000** / est. $12,000-$15,000 / sold 11-75 SPB for $11,000 / 2-4 SBP.

Furniture

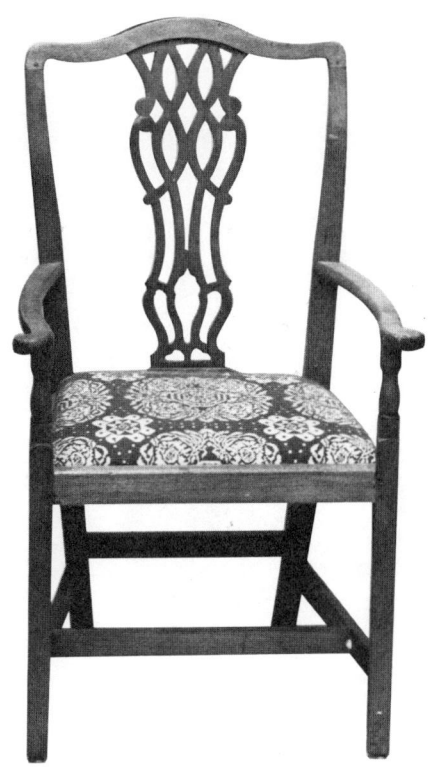

37. Armchair, birch, possibly New England, 1760-1810 / **$340** / 1-6 Garth's.

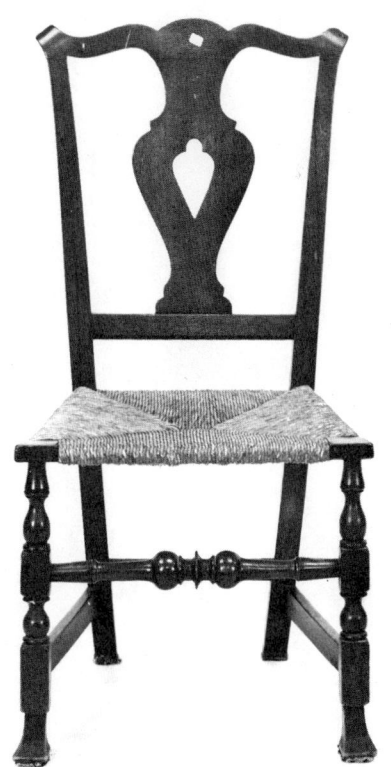

38. Side chair, walnut, probably New England, 1755-95 / **$750** / est. $300-500 / 10-27 Skinner.

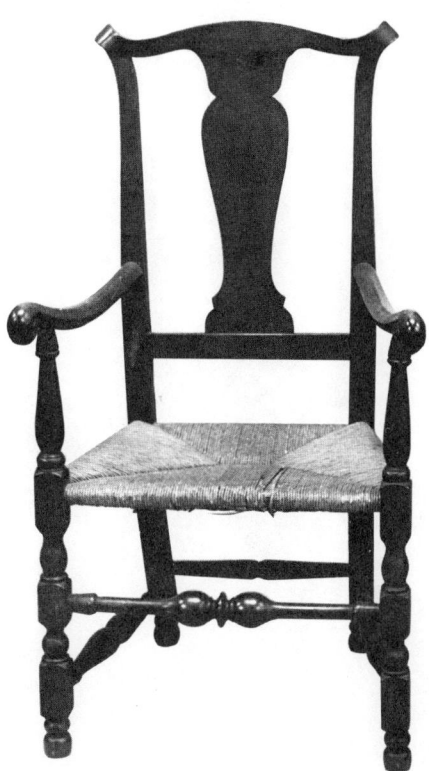

39. Armchair, cherry, alligatored varnish finish, feet ended out 2½ inches, possibly Conn., 1755-1810 / **$700** / 7-28 Garth's.

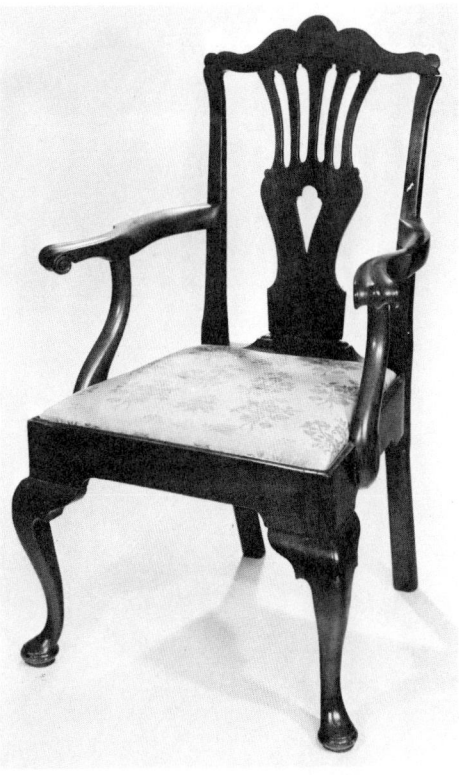

40. Armchair, walnut, Md. or southern, 1755-95 / **$1,200** ($1,320) / est. $2,000-2,500 / 3-10 Christie's.

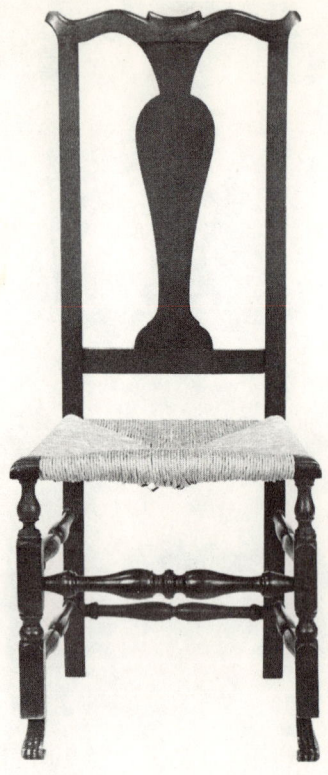

41. Side chair, mahogany, probably New England, 1755-95 / **$600** / est. $600-800 / 10-27 Skinner.

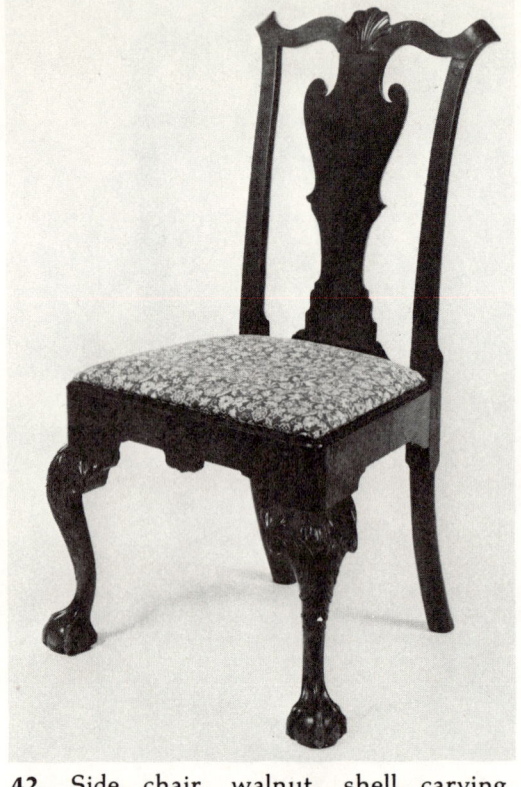

42. Side chair, walnut, shell carving missing from seat rail, Philadelphia, 1755-95 / **$1,300** / est. $2,000-3,000 / 11-18 SPB.

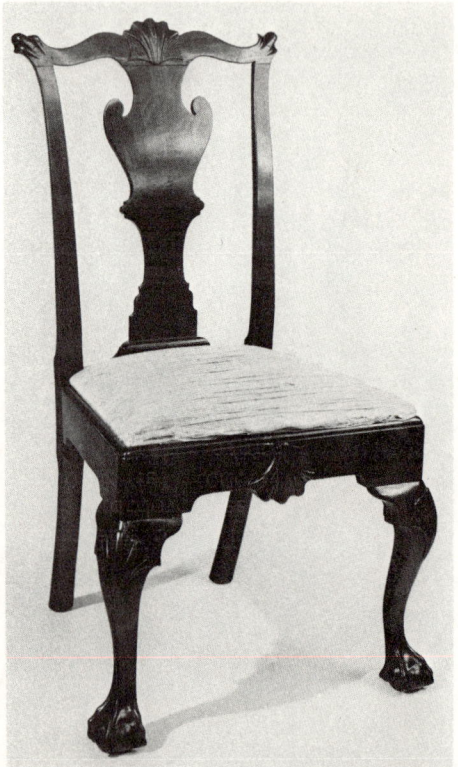

43. Side chair, mahogany, Philadelphia, circa 1760 / **$5,500** / est. $3,000-5,000 / 2-4 SPB.

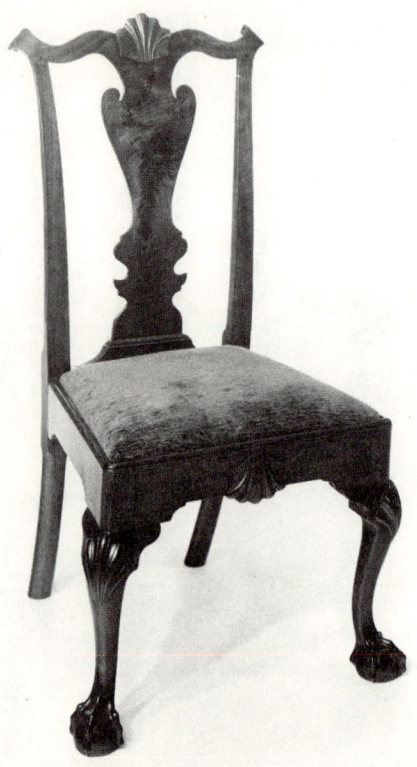

44. Side chair, walnut, Philadelphia, 1755-95 / **$5,500** ($6,050) / est. $2,000-2,500 / dealer / 10-21 Christie's.

Furniture 27

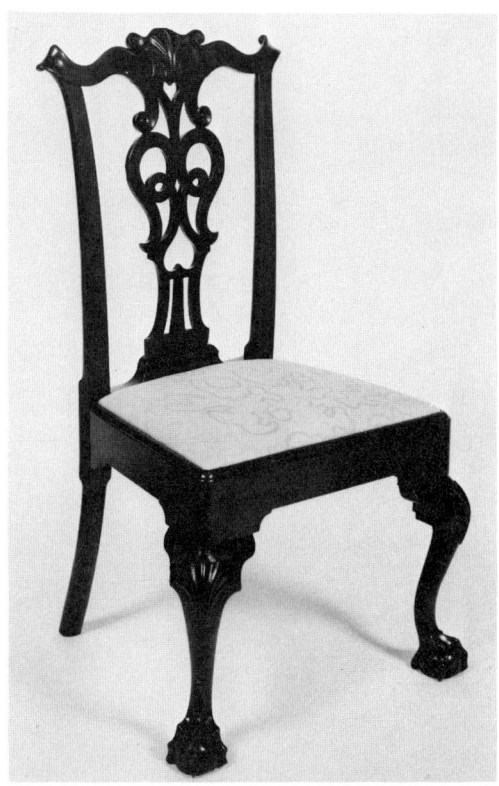

45. Side chair, walnut, Philadelphia, 1750-70 / **$7,500** / est. $6,000-8,000 / dealer / provenance: Israel Sack, Inc. N.Y. / 2-4 SPB.

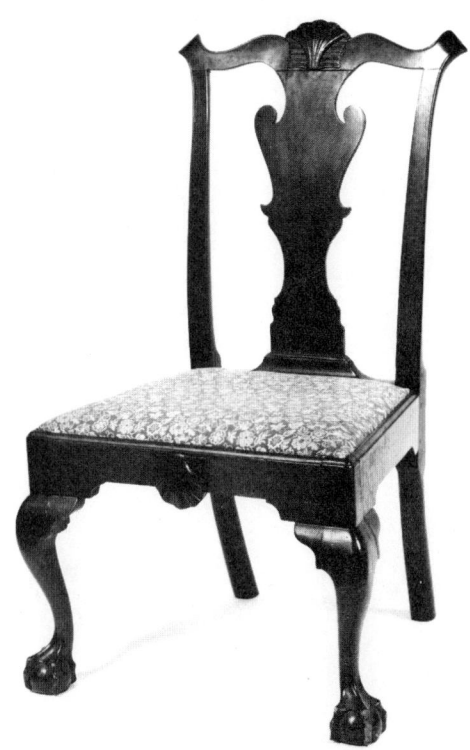

46. Side chair, walnut, Philadelphia, 1755-95 / **$2,300** / est. $2,000-2,500 / 11-18 SPB.

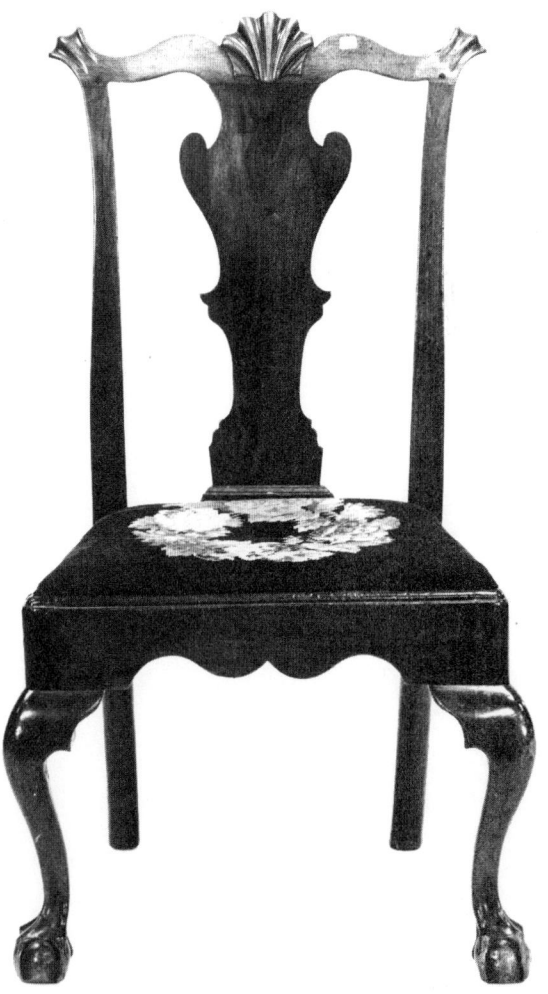

47. Side chair, mahogany, Philadelphia, 1755-95 / **$2,700** / est. $1,500-2,000 / provenance: the family of John Dickinson, member of original Continental Congress / 9-22 Skinner.

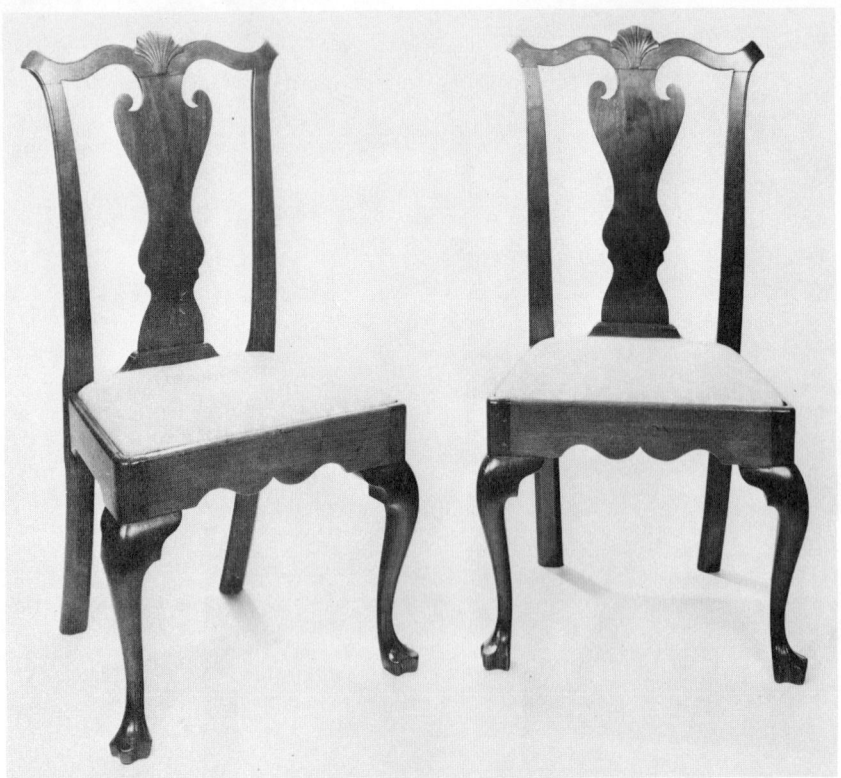

48. Pair of side chairs, walnut, some early repairs, both chairs branded on rear seat rail with a heart between brackets, probably Philadelphia, 1755-95 / **$3,000** ($3,300) / est. $4,000-6,000 / 3-10 Christie's.

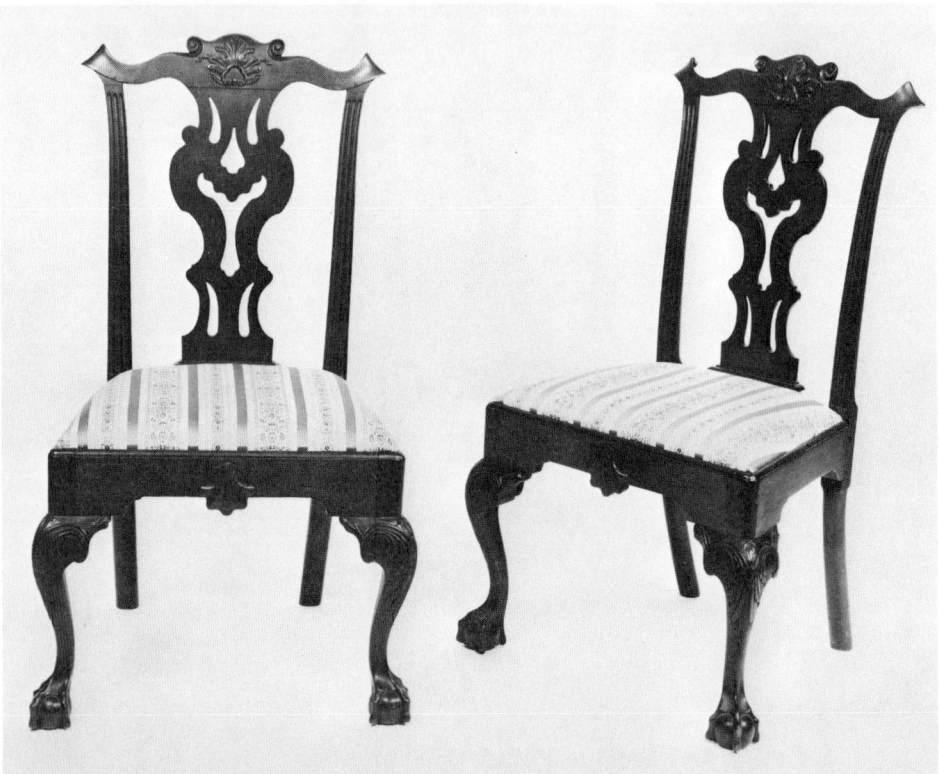

49. Pair of side chairs, mahogany, attributed to William Wayne, Philadelphia, circa 1770 / **$22,000** / est. $15,000-20,000 / private / illus. in Hornor, no. 334 / 4-29 SPB.

Furniture

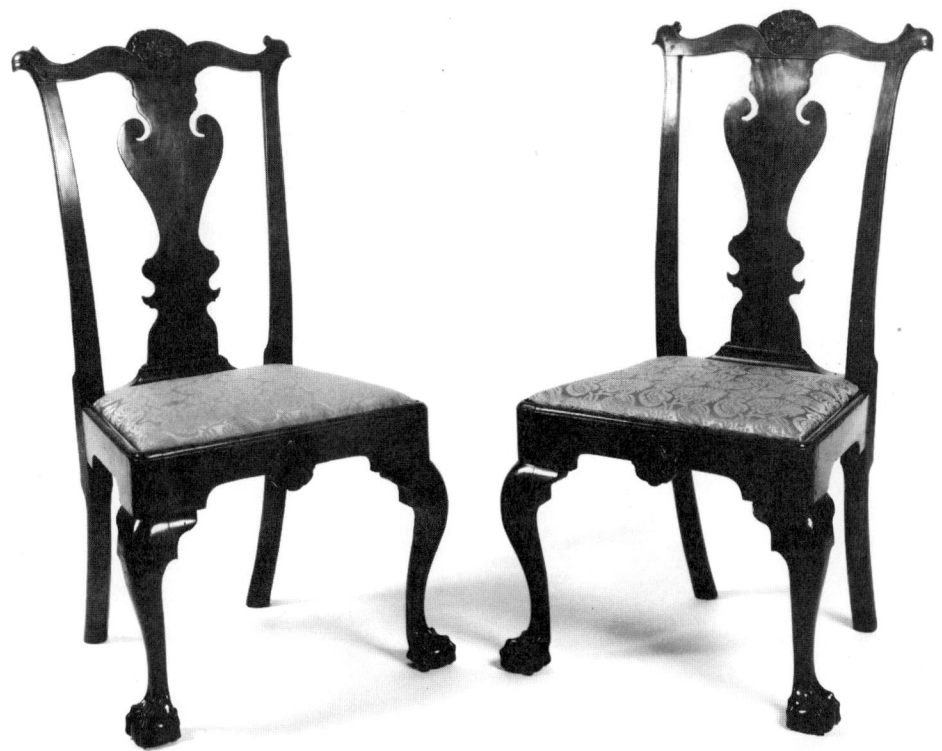

50. Pair of side chairs, walnut, Philadelphia, 1755-95 / **$11,500** / est. $15,000-20,000/ 11-18 SPB.

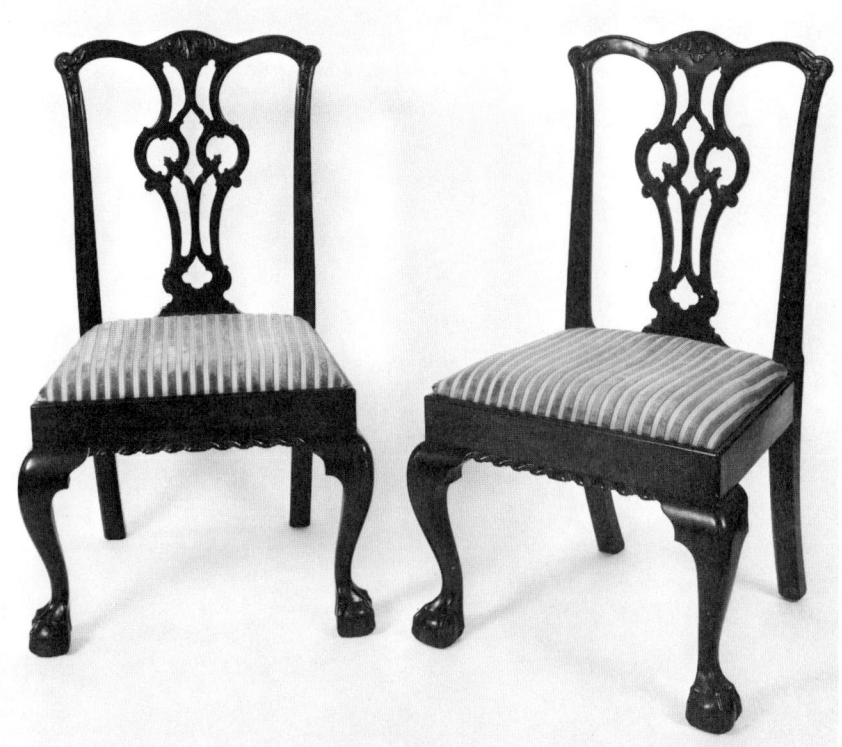

51. Set of three side chairs (two shown), mahogany, N. Y., 1755-95 / **$7,000**/ est. $10,000-15,000 / provenance: the Marvin-Jarvis families; another chair from set illus. in Downs, no. 148 / 9-30 SPB.

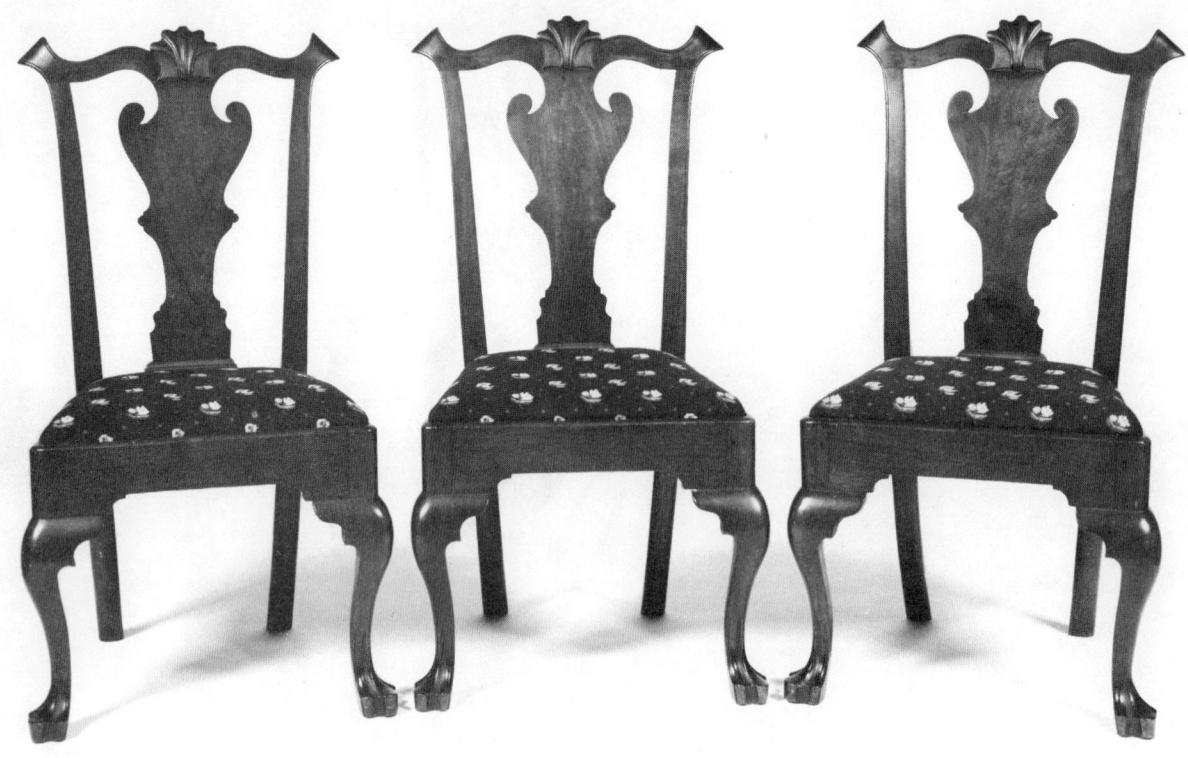

52. Set of three side chairs, curly walnut, Philadelphia, 1750-70 / **$12,000** / est. $10,000-15,000 / 2-3 SPB.

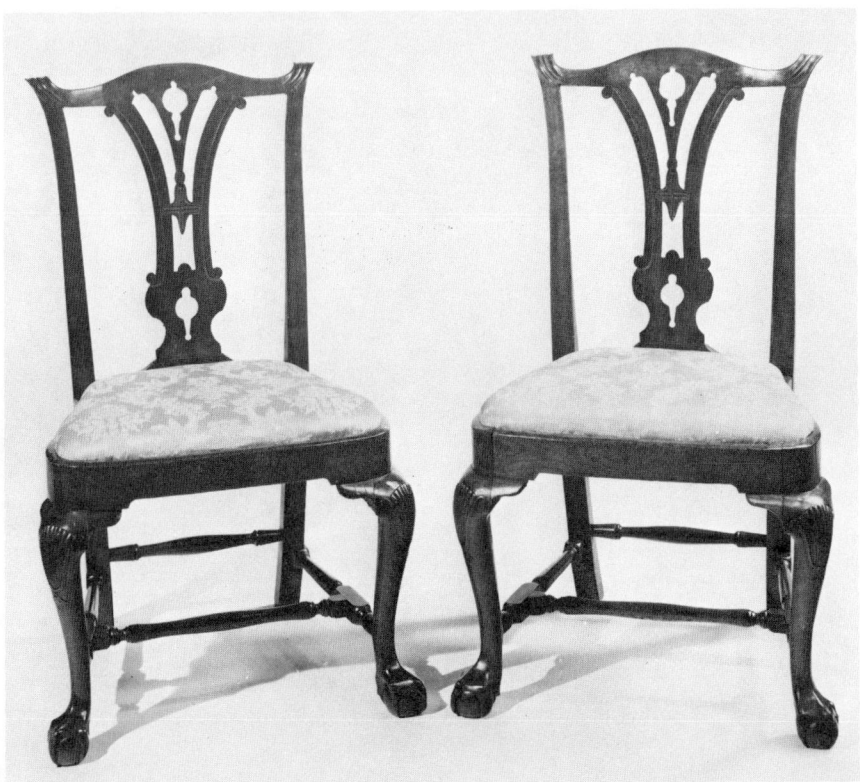

53. Set of six side chairs (two shown), cherry, Mass. or R.I., 1760-95 / **$15,000** / est. $15,000-20,000 / dealer / 2-4 SPB.

Furniture

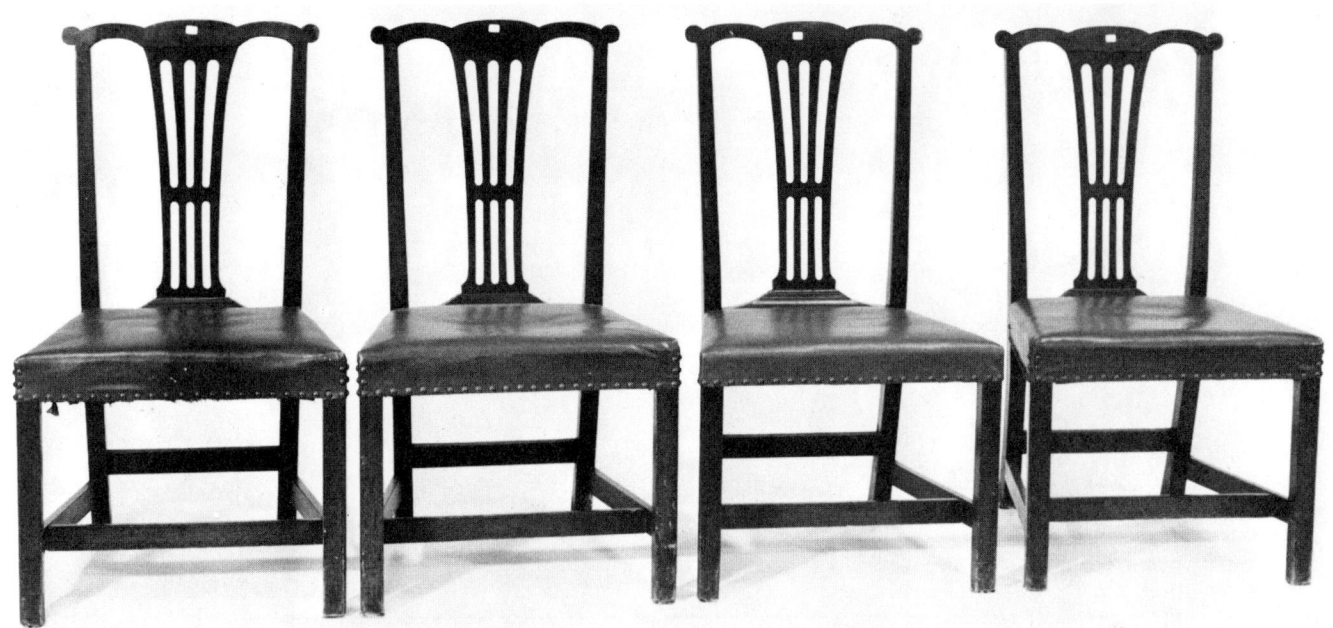

54. Set of four side chairs, cherry, probably New England, late 18th c. / **$1,300** / est. $1,500-2,000 / 10-27 Skinner.

55. Side chair, repainted, some repairs, by Samuel Gragg, Boston, patented 1808 / **$1,225** / private / underbidder: the Boston Museum of Fine Arts / 1-21 Julia.

56. Set of six side chairs (one shown), maple and pine, paint decorated in yellow, ochre, and black, marked "Warranted," New England, circa 1830 / **$6,250** / dealer / 7-3 Oliver.

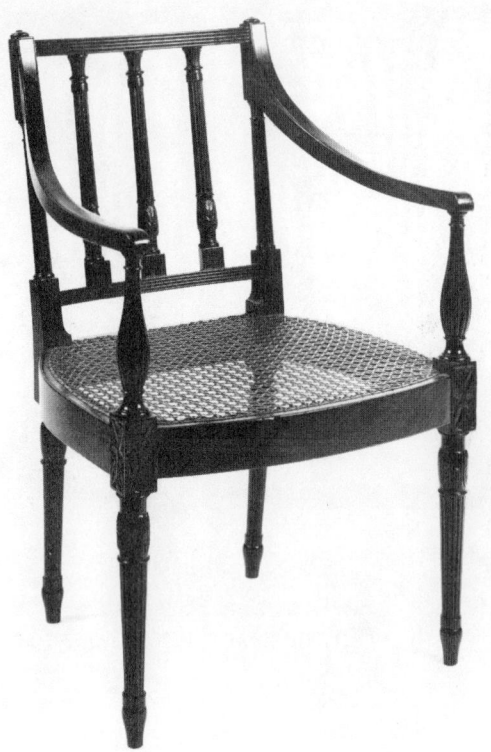

57. Armchair, mahogany, Haines-Connelly school, Philadelphia, 1790-1815 / **$3,100** / est. $1,500-2,000 / private / 11-18 SPB.

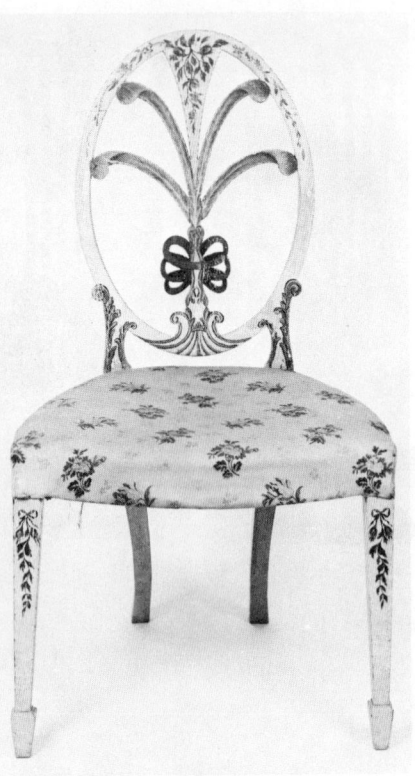

58. Side chair, paint decorated, restoration to feet and splat, Philadelphia, circa 1795 / **$5,500** / est. $6,000-8,000 / private / 4-29 SPB.

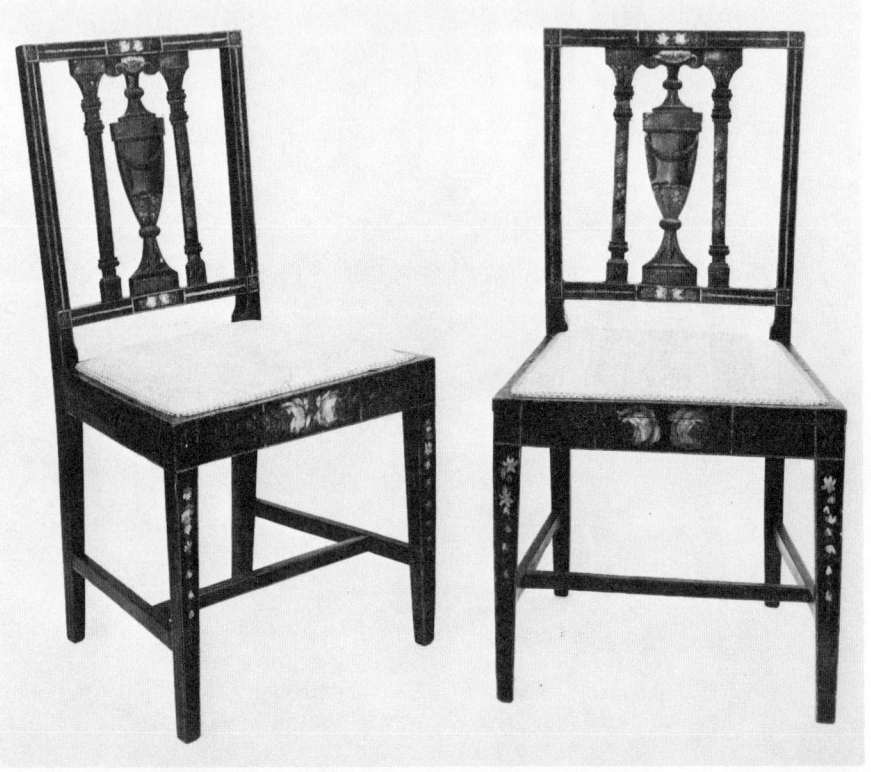

59. Pair of side chairs, restoration to paint decoration, seats upholstered over caning, attributed to John and/or Thomas Seymour, Boston, circa 1795 / **$2,000** / est. $5,000-7,000 / dealer / 9-30 SPB.

Furniture

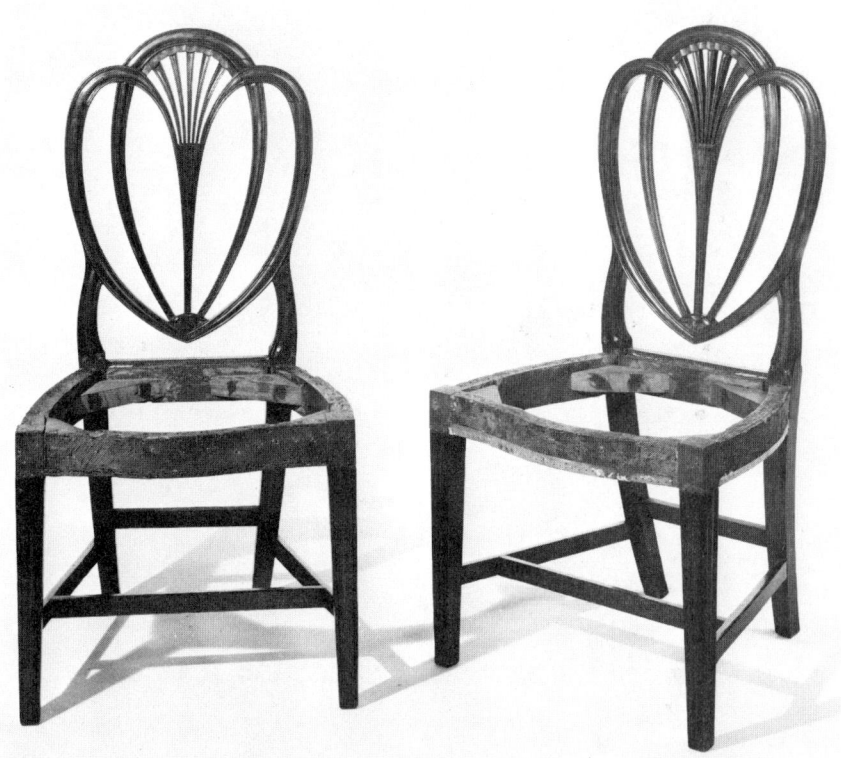

60. Pair of side chairs, mahogany, Philadelphia, circa 1790 / **$2,000** / est. $2,000-2,500 / 2-4 SPB.

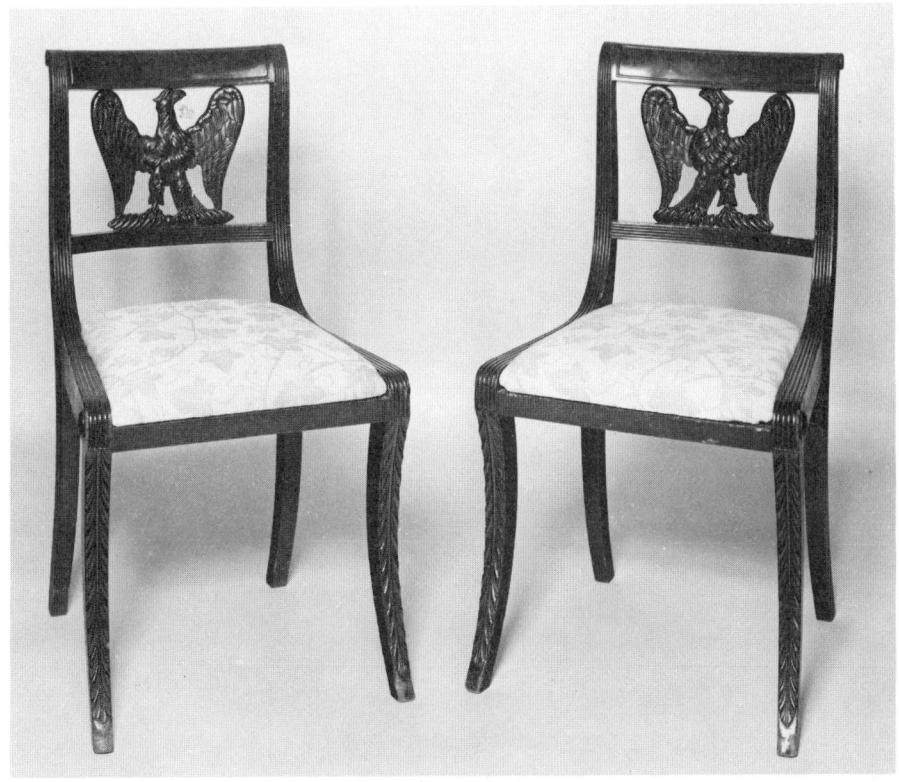

61. Set of four side chairs (two shown), mahogany, attributed to Duncan Phyfe, New York, circa 1815 / **$32,000** ($35,200) / est. $6,000-8,000 / dealer/ provenance: descended from Gov. DeWitt Clinton in direct line to Malcolm Field, Sloatsburg, N.Y.; exhibited Museum of the City of New York, 1934 / 10-21 Christie's.

62. Pair of armchairs, mahogany, attributed to Samuel McIntyre, Salem, Mass., circa 1800 / **$7,000** / est. $7,000-9,000 / provenance: reputedly from the Pierce-Nichols House, Salem (designed and built by McIntyre) / 4-29 SPB.

63. Wing chair, inlaid mahogany, probably New England, circa 1800 / **$1,950** / est. $1,200-1,500 / 10-27 Skinner.

64. Wing chair, cherry, probably New England, 1760-1810 / **$1,300** / 7-25 Withington.

Furniture

65. Set of five side chairs (two shown), paint decorated on cream-colored ground, probably New York, circa 1810 / **$1,800** / est. $500-700 / 11-18 SPB.

66. Wing chair, mahogany, probably Mass., 1740-60 / **$3,300** / 7-25 Withington.

67. Wing chair, walnut, probably R.I., 1740-60 / **$8,000** ($8,800) / est. $8,000-10,000 / 3-10 Christie's.

68. Windsor rocking chairs, probably New England, 1st half 19th c. Left to right: old black paint / **$130**; old black paint with gilt decoration / **$700** / dealer / 7-25 / Withington.

69. Sack-back Windsor chair, old but not original black paint, New England, 1770-1800 / **$900** / 10-13 Garth's.

70. Armchair, laminated rosewood, attributed to John Belter, New York, circa 1850 / **$7,000** / est. $3,000-5,000 / 10-27 SPB.

Furniture

71. Pair of side chairs (one shown), laminated rosewood, attributed to John Belter, New York, circa 1850 / **$10,000** / est. $3,000-5,000 / 10-27 SPB.

72. Three-piece parlor suite including sofa and two gentleman's chairs, laminated rosewood, slight damage to one front leg of sofa, grape and rose design, attributed to John Belter, N.Y., mid-19th c. / **$42,000** (record for Belter furniture) / private / provenance: private collector, Pass Christian, Miss. / 11-28 Morton's.

73. Bow-back Windsor amrchair, painted black-green, possibly Penn., circa 1800 / **$950** / est. $600-800 / 11-18 SPB.

74. Fanback Windsor side chair, scroll carved ears / **$750** / 6-12 Pennypacker.

75. Fan-back Windsor side chairs, New England, late 18th c. Left to right: black paint over original green, reeded spindles / **$1,100**; late dark red paint / **$750**; black paint over original green / **$750** / 7-25 Withington.

76. Pair of fan-back Windsor side chairs, later black paint over mostly scraped off old green paint / **$2,050** / dealer / 8-10 F.O. Bailey.

Furniture

77. Comb-back Windsor chair, probably New England, late 18th c. / **$3,300** / 6-12 Pennypacker.

78. Child's fan-back Windsor armchair, painted black, probably New England, late 18th c. / **$1,300** / est. $2,000-3,000 / provenance: Stokes collection, Philadelphia; illus. in Nutting, no. 2513 / 11-18 SPB.

79. Braced continuous-arm Windsor chair, dark brown paint with striping, branded "I. Dewitt," Conn., circa 1795 / **$1,100** / est. $1,000-1,500 / dealer / 2-4 SPB.

80. Fan-back Windsor side chair, 19th c., reddish brown paint with gilt decoration, New England, late 18th c. / **$1,350** / dealer / 7-25 Withington.

81. Fan-back Windsor side chair, reddish brown paint, possibly Conn., circa 1780 / **$1,900** / est. $600-800 / 2-4 SPB.

82. Braced continuous-arm Windsor chair, branded "E.B: Tracy," Lisbon, Conn., 1764-1803 / **$2,500** / 4-21 Skinner.

83. Fan-back Windsor armchair, painted black with yellow striping, probably Conn., circa 1790 / **$2,100** / est. $1,500-2,000 / private / 11-18 SPB.

84. Braced fan-back Windsor side chair, traces of red-brown paint, probably New England, 1770-1800 / **$2,000** / est. $750-1,000 / private / 11-18 SPB.

Furniture

85. Braced continuous-arm Windsor chair, refinished, attributed to Ebenezer Tracy, Lisbon, Conn., 1764-1803 / **$2,200** / est. $700-900 / 9-9 SPB.

86. Low-back Windsor chair, painted black, Philadelphia, 1750-80 / **$3,750** / est. $2,000-3,000 / provenance: John Gordon Gallery, N.Y. / 2-4 SPB.

87. Fan-back Windsor side chair, old black paint, branded "Henzey," Philadelphia, 1765-90 / **$3,800** / dealer / 7-25 Withington.

88. Comb-back Windsor chair, painted green, New England, circa 1800 / **$2,600** / est. $1,500-2,000 / 2-4 SPB.

89. Bow-back Windsor side chair, old red paint, probably New England, 1800-30 / **$325** / 6-23 Morrill.

90. Pair of bow-back Windsor side chairs, backs have brass braces, circa 1810 / **$650** / est. $400-600 / 9-9 SPB.

91. Pair of braced continuous-arm Windsor chairs, worn olive-green paint with earlier paint beneath, probably New England, 1760-1800 / **$4,200** / 1-6 Garth's.

Furniture

92. Assembled set of four bow-back Windsor side chairs, refinished, one chair repaired, probably New England, late 18th c. / **$2,900** / est. $2,500-3,000 / 10-27 Skinner.

93. Set of six bow-back Windsor side chairs (three shown), old gray paint, 19th c. / **$4,000** / 4-21 Skinner.

94. Settee, original paint, circa 1830, l. 82 / **$625** / 9-22 Garth's.

95. Settee, original paint decoration, probably Penn., circa 1830 / **$775** / 5-5 Garth's.

Furniture

96. Fireside bench, pine, hinged-lid hutch, probably Penn., mid-19th c. / **$525** / 6-12 Pennypacker.

97. Daybed, cherry, restoration to stretchers, Conn., circa 1760, l. 66½ / **$4,250** / est. $5,000-7,000 / dealer / provenance: collection Luke Vincent Lockwood, Conn., collection Frederick Barbour, Conn., and Ginsburg and Levy, Inc., N.Y.; illus. in Lockwood, no. 645 / 2-4 SPB.

98. Daybed, mahogany, probably Conn., 1755-95, l. 76 / **$3,000** /est. $3,000-5,000 / 9-30 SPB.

99. Rocking settee, original decoration and yellow paint, possibly Conn., circa 1830, l. 78 / **$850** / 9-22 Garth's.

Furniture

100. Settee, refinished, circa 1820, l. 75½, h. to seat 16 / **$950** / 3-17 Garth's.

101. Bow-back Windsor settee, old brownish red paint, probably New England, early 19th c. / **$5,800** / dealer / 7-25 Withington.

48

Furniture

102. Settee, original paint decoration, possibly New England, circa 1810, l. 37 / **$2,200** / 10-13 Garth's.

103. Sofa, stenciled mahogany, N. Y., circa 1825, l. 89 / **$2,500** / est. $2,000-3,000 / 2-3 SPB.

Furniture

104. Sofa, mahogany and tiger maple, one leg replaced, probably Mass., circa 1810 / **$1,200** / est. $2,000-2,500 / 10-27 Skinner.

105. Sofa, laminated rosewood, attributed to John Belter, New York, circa 1850, l. 61½ / **$3,800** ($4,180) / est. $2,500-3,500 / 10-21 Christie's.

106. Sofa, mahogany, minor repairs, possibly Mass., 1755-95, l. 78 / **$3,500** / est. $6,500-8,500 / dealer / 10-27 Skinner.

107. Four-piece parlor suite including an armchair, a daybed, and two side chairs (not shown), laminated rosewood, attributed to John Belter, New York, circa 1848 / **$2,250** / est. $3,000-5,000 / private / 10-31 Freeman.

Furniture

108. Sofa, walnut, five legs patched on outer edges, Philadelphia, 1760-95, l. 95½ / **$15,000** / est. $10,000-12,000 / 2-4 SPB.

109. Tavern table, maple and pine, New England or Long Island, 1750-1800, 38¼ x 24 / **$1,500** / est. $800-1,200 / 9-9 SPB.

110. Tavern table, maple, cut down, Conn., probably Fairfield area, 1720-60, 41 x 25 / **$1,700** / est. $2,000-3,000 / 9-30 SPB.

Furniture

111. Tavern table, maple, painted light blue, New England, 1730-1800, h. 26 / **$2,800** / est. $1,200-1,500 / dealer / 10-27 Skinner.

112. Tavern table, maple, New England, 1720-1800 / **$3,300** / 4-21 Skinner.

113. Tavern table, cherry, drawer front repaired, dark brown paint over blue, New England, 1720-1800 / **$2,600** / 4-21 Skinner.

114. Tavern table, tiger maple and pine, untouched condition, New England, 1720-1800 / **$4,000** / 4-21 Skinner.

Furniture

115. Tavern table, maple, old red paint, New England, 1720-1800 / **$4,800** / 7-7 Withington.

116. Tea table, tiger maple, one leg probably replaced, New England, 1740-60 / **$5,900** / 7-25 Withington.

117. Tavern table, maple and pine, old red paint, untouched condition, New England, 1720-60 / **$6,750** / 7-25 Withington.

118. Tavern table, cherry, brasses apparently original, repairs to top, Conn., 1740-1800, 31¼ x 26½ / **$6,750** / est. $2,000-3,000 / dealer/ 4-29 SPB.

Furniture

119. Tea table, cherry, four knee brackets missing, minor early repairs, possibly Conn., 1740-60, 27 x 26 / **$15,000** / est. $8,000-10,000 / dealer / 10-27 Skinner.

120. Tea table, cherry, old finish, Conn. or R.I., circa 1780, 31¼ x 21 / **$4,400** / est. $3,000-5,000 / 11-24 Bourne.

121. Tea table, maple, all original, New England, 1740-1800 / **$10,000** / 7-25 Withington.

122. Serving table, mahogany, replaced marble top, N. Y., 1755-95, w. 39¼" / **$36,000** ($39,600) / est. $40,000-60,000 / dealer / 10-21 Christie's.

123. Swing-leg table, cherry, branded "W. Evans," Conn. or N.H., 1740-60, 40½ x 27¾ / **$1,500** ($1,650) / est. $2,000-2,500 / 10-21 Christie's.

Furniture

124. Pembroke table, inlaid mahogany, one working and one mock drawer, restoration to inlay, N.Y., 1790-1815, 33 open x 27¾ / **$2,400** / est. $1,500-2,000 / sold 4-73 SPB for $1,500 / 4-29 SPB.

125. Swing-leg table, new black paint, all feet replaced, branded "E.B. Moulton," New England, 1740-60 / **$3,300** / 7-25 Withington.

126. Swing-leg table, cherry, probably New England, 1740-60, 36 open x 27¾ / **$3,700** / 10-13 Garth's.

127. Swing-leg table, maple, New England, 1740-60, 60½ open x 53½ / **$3,750** / est. $2,500-3,000 / 9-22 Skinner.

Furniture

128. Swing-leg table, mahogany, Philadelphia, 1755-95, 53½ open x 28¼ / **$4,250** / est. $4,000-6,000 / provenance: John S. Walton, N.Y. / 11-18 SPB.

129. Gate-leg table, maple, reddish brown paint, New England, 1720-40, 40 open x 26¼ / **$4,500** / est. $3,500-4,000 / dealer / provenance: Roger Bacon Antiques, Exeter, N.H. / 2-4 SPB.

130. Butterfly table, cherry, old varnish on base, all original but position of leaves switched, possibly Conn., 1700-40, 45 open x 27 / **$9,500** / 10-13 Garth's.

131. Trestle-base butterfly table, sycamore and maple, restorations, probably R.I., 1700-35, 36½ open x 24 / **$13,500** / est. $6,000-8,000 / dealer as agent for private collector / 9-30 SPB.

132. Swing-leg table, walnut, New York, 1760-70, 58¾ open x 28¼ / **$10,000** / est. $7,500-10,000 / private / exhibited at Metropolitan Museum of Art, 1934; listed (incorrectly as mahogany) in 1786 inventory of Baltus Van Kleek, Flushing, N.Y.; cited in Downs / 2-4 SPB.

Furniture

133. Card table, inlaid mahogany, probably Boston, 1790-1815, 36⅞ open x 30¼ / **$1,800** / est. $1,500-2,500 / 4-29 SPB.

134. Pair of card tables, inlaid mahogany, some veneer missing from lower part of legs, probably New England, 1790-1815, 36 x 28 / **$3,300** / est. $2,000-2,250 / 10-27 Skinner.

135. Card table, mahogany, possibly Va., 1760-95, 29¾ x 29 / **$4,000** ($4,400) / est. $1,200-1,500 / State Department / 10-21 Christie's.

136. Card table, mahogany, bird's-eye maple, and brass, possibly Philadelphia, circa 1810, 36 open x 30 / **$2,500** ($2,750)/ est. $3,500-4,500 / dealer / 10-21 Christie's.

Furniture

137. Card table, mahogany, attributed to John Goddard, Newport, R.I., circa 1770, 34 x 27 / **$40,000** / est. $60,000-80,000 / dealer / 11-18 SPB.

138. Card table, mahogany, refinished, Boston, 1760-80, 32¾ x 28½ / **$9,000** / est. $12,000-15,000 / provenance: Israel Sack, Inc., N.Y.; exhibited at Boston Museum of Fine Arts, 1972 / 2-4 SPB.

139. Card table, walnut, Philadelphia, 1755-95, 35 x 28½" / **$50,000** ($55,000) / est. $40,000-60,000 / dealer / provenance: family of Judge Jasper Yeates; exhibited at Mount Pleasant (Fairmount Park, Philadelphia), 1961-73, and Philadelphia Museum of Art, 1973-78; illus. in Hornor, no. 33 / 10-21 Christie's.

141. Card table, inlaid mahogany, probably Mass., 1790-1815 / **$2,700** / 7-25 Withington.

140. Triple-top card table, mahogany, brass plaque on underside of top reads "Made by John Goddard," Newport, R.I., 1760-75, 30 x 28 / **$85,000** ($93,500) / no est. / private / provenance: the Broome-Livingston families, Schenectady, N.Y. / 10-21 Christie's.

Furniture

142. Chair table, pine and maple, old red paint, probably Maine or Canada, probably early 19th c. / **$2,300** / dealer / 6-23 Morrill.

143. Chair table, pine, old worn blue paint on base over old red paint, yellow over blue paint on top, rods replaced, left part of scroll at base of compartment is old replacement, early 18th c., dia. 41 x 27½ / **$6,750** / private / illus. in Russell Hawes Kettell, *The Pine Furniture of Early New England*, no. 72, and in Nutting no. 1770 / 11-25 Garth's.

144. Chair table, maple and pine, traces of original red paint, possibly New England, circa 1800, top 54 x 40 / **$1,900** / est. $1,500-2,000 / dealer / 9-22 Skinner.

145. Trestle table, pine, New England, late 18th - early 19th c., top 108 x 34, h. 29½ / **$5,000** / est. $3,000-4,000 / 9-22 Skinner.

146. Banquet table, mahogany, possibly Mass., 1790-1815, 149½ open x 29 / **$6,250** / est. $5,000-6,000 / 9-22 Skinner.

Furniture 69

147. Tip-top stand, probably New England, 1790-1815 / **$650** / 7-25 Withington.

148. Stand, dish top, old red paint, New England, 1790-1815 / **$800** / 7-25 Withington.

149. Tilt-top stand, bird's-eye maple, probably New England, circa 1800 / **$375** / 9-14 Julia.

150. Pair of stands, inlaid birch, New England, 1790-1815 / **$1,700** / 7-25 Withington.

151. Tip-top stands, New England, 1790-1815. Left to right: **$900; $625; $825** / 7-25 Withington.

Furniture

152. Stand, maple and chestnut, New England, 1790-1815 / **$900** / 4-21 Skinner.

153. Tip-top stand, inlaid birch, New England, 1790-1815 / **$900** / 7-25 Withington.

154. Stand, inlaid, possibly New England, circa 1810, h. 26 / **$1,550** / est. $900-1,200 / 10-27 Skinner.

155. Tip-top stand, mahogany, probably New England, circa 1790 / **$1,550** / 7-25 Withington.

156. Tip-and-turn table, walnut, Penn., 1755-95, dia. 33¼ / **$2,700** / est. $1,750-2,000 / 10-31 Freeman.

157. Tip-and-turn table, mahogany, dish top, two feet have lost part of claw, attributed to Thomas Affleck, Philadelphia, circa 1770, dia. 31½ x h. 28 / **$3,300** / 10-13 Garth's.

158. Tip-and-turn stand, walnut, some repairs to birdcage and standard, Philadelphia, 1755-95, dia. 21¼ x h. 27 / **$2,800** / est. $2,000-3,000 / 11-18 SPB.

159. Stand, birch, untouched condition, probably New England, late 18th c. / **$1,600** / dealer / 9-14 Julia.

Furniture

160. Tip-and-turn stand, mahogany, Philadelphia, 1755-95, dia. 23½ x h. 29¼ / **$3,400** / est. $3,000-4,000 / 11-18 SPB.

161. Stand, old finish, attributed to the Dunlap workshop, N.H., circa 1800 / **$3,500** / 7-25 Withington.

162. Stand, inlaid mahogany, attributed to John Dunlap II, N.H., circa 1800, h. 29¼ / **$5,500** / est. $3,000-5,000 / 2-4 SPB.

163. Stand, cherry, probably Mass., 1790-1815 / **$650** / 7-25 Withington.

164. Stand, inlaid cherry, original brasses, New England, circa 1820 / **$1,600** / est. $800-1,000 / 9-22 Skinner.

165. Stand, cherry, New England, circa 1800, 16¼ x 27 / **$1,100** / est. $300-500 / dealer / 9-30 SPB.

166. Sewing stand, maple and birch, paint decorated, pull-out work basket, probably Portsmouth, N.H., circa 1800, 15½ x 28½ / **$1,600** / est. $2,000-3,000 / 2-4 SPB.

167. Stand, inlaid mahogany, Boston or Salem, Mass., circa 1800, 18 x 27½ / **$1,000** ($1,100) / est. $1,200-1,500 / 3-1 Christie's.

Furniture

168. Stand, old red paint or stain, attributed to the Dunlap workshop, N.H., circa 1800 / **$4,600** / 7-25 Withington.

169. Stand, inlaid satinwood, attributed to John and/or Thomas Seymour, Boston, circa 1805, 19¾ x 28¼ / **$6,500** / est. $5,000-7,000 / dealer / provenance: the Bradlee-Doggett families, Boston, and Harry Arons, Antiques, Ansonia, Conn.; illus. in Stoneman, *A Supplement to John and Thomas Seymour*, no. 51; bears a loan exhibition label from the Museum of Fine Arts, Boston / 9-30 SPB.

170. Corner washstand, paint decorated, probably New England, 19th c. / **$450** / 7-25 Withington.

171. Corner washstand, inlaid mahogany, lower shelf or stretchers apparently missing, Mass., circa 1800, 25½ x 46 / **$1,100** / est. $700-900 / 9-30 SPB.

172. Screw-post candlestand, walnut, probably New England, probably 18th c., h. 32 / **$1,300** / est. $400-600 / illus. in Nutting, no. 1337 (not indicated in sale catalog) / 4-29 SPB.

173. Screw-post candle stand, probably New England, probably 18th c. / **$900** / 7-7 Withington.

174. Cellarette, walnut, upper case with two false drawers and fitted with twelve bottles, Philadelphia, 1760-80, 22 x 33¾ / **$8,000** / est. $3,500-5,000 / dealer / ex-coll. Mrs. J. Amory Haskell; sold 4-73 SPB for $3,600 / 2-4 SPB.

175. Cellarette, maple and pine, refinished, fitted with twelve bottles, New England, 1740-1800 / **$1,600** / 7-25 Withington.

Furniture

176. Pole screen, mahogany, attributed to the Goddard-Townsend workshop, Newport, R.I., 1760-80, h. 58½ / **$7,000** ($7,700) / est. $6,000-8,000 / 3-10 Christie's.

177. Serving table, inlaid mahogany, North Carolina Piedmont, circa 1800, 32¼ x 42¼ / **$3,050** / 9-29 FACP.

178. Huntboard, southern yellow pine, refinished, replaced brasses, probably circa 1800 / **$700** / dealer / 8-10 F.O. Bailey.

179. Serving table, cherry, probably New England, 19th c., w. 30 / **$3,700** / 7-25 Withington.

180. Sideboard, mahogany, brasses apparently original, some restoration, possibly New York, circa 1790, 69½ x 38 / **$1,500** / est. $2,500-3,500 / 9-22 Skinner.

181. Serpentine-front sideboard, inlaid mahogany, restored, N. Y., 1790-1810, 69 x 39¾ / **$1,600** / est. $2,500-3,500 / 2-3 SPB.

Furniture

182. Serpentine-front sideboard, inlaid mahogany, signed "James You[ng]," New York, circa 1810, 69¾ x 39¾ / **$3,000** / est. $2,000-4,000 / 2-3 SPB.

183. Sideboard, inlaid mahogany, New York, 1790-1815, 60 x 39½ / **$4,750** / 9-29 FACP.

184. Two-tier sideboard, inlaid mahogany and bird's-eye maple, attributed to John and/or Thomas Seymour, Boston, circa 1800, 73 x 46 / **$5,500** / est. $6,000-8,000 / sold 5-75 SPB for $4,250 / 2-4 SPB.

Furniture

185. Chest over drawer, pine, painted blue-black, probably Long Island, late 18th c., 36¼ x 37 / **$1,000** / est. $500-700 / illus. in Dean F. Failey, *Long Island Is My Nation*, no. 121 (not indicated in sale catalog) / 9-9 SPB.

186. Chest over drawer, pine, grain decorated, original brasses, New England, 1760-1810, w. 33 / **$1,050** / 4-21 Skinner.

187. Chest over drawers, pine, paint decorated in red and black, restorations, New England, circa 1800, 41 x 44 / **$550** / est. $1,000-1,500 / sold 11-76 SPB for $1,400 / 11-18 SPB.

188. Chest over drawer, paint decorated, probably New England, circa 1810, 44 x 37 / **$1,050** ($1,155) / est. $600-800 / 10-21 Christie's.

189. Child's chest over drawer, pine, original blue-gray paint, probably New England, probably 18th c., 28 x 22 / **$850** / est. $700-1,000 / 9-22 Skinner.

190. Sea chest, walnut, rope handles, 19th c., 37 x 17½ / **$1,200** / est. $600-800 / 4-29 SPB.

191. Chest over drawer, pine, old red paint, probably New England, early 19th c. / **$1,500** / 7-7 Withington.

192. Chest over drawer, pine, paint decorated, New England, early 19th c. / **$1,600** / 7-7 Withington.

Furniture

193. Chest over drawers, pine, original brasses, original red paint, New England, 2nd half of 18th c., 36½ x 40 / **$1,600** / 10-13 Garth's.

194. Chest over drawers, cherry and pine, converted to chest of drawers, attributed to the Dominy workshop, Long Island, circa 1800, 31½ x 33 / **$2,000** / est. $700-900 / 9-9 SBP.

195. Chest, tiger maple, probably New England, 18th or early 19th c., 51 x 18½ / **$2,050** / 10-13 Garth's.

196. Chest over drawer, oak, pine, and walnut, traces of original red and black paint, top early but not original, Mass., 1670-1710, w. 37 / **$3,200** / est. $3,000-4,000 / 10-27 Skinner.

197. Chest over drawers, mustard paint over old red, retains most of original brasses, New England, 1740-60, 40 x 49 / **$2,600** / 4-21 Skinner.

198. Chest over drawers, poplar, original blue, mustard, salmon and red paint, original brasses, some restoration to feet, center drawer an old replacement, Penn., inscribed "Elizabeth Baurin" and "1786," 49½ x 27 / **$3,600** / 10-13 Garth's.

199. Chest over drawers, pine, paint decorated in green, New England, probably N.H., circa 1840 / **$7,000** / dealer / 7-3 Oliver.

Furniture

200. Chest, oak and pine, refinished, eastern Mass., probably Ipswich or Salem, 1670-1710, 44¾ x 30 / **$7,500** / est. $10,000-15,000 / dealer / provenance: Harry Arons, Antiques, Ansonia, Conn. / 9-30 SPB.

201. Chest over drawers, pine, old red paint, original brasses, minor repairs, New England, 1720-35 / **$4,200** / 7-7 Withington.

202. Hadley chest, oak and pine, restorations (front once cut and hinged to form a desk), Mass. or Conn., 1680-1710, 44 x 37½ / **$9,000** / est. $10,000-15,000 / listed in Luther / 2-4 SPB.

203. "Sunflower" chest, oak, pine, and maple, Hartford County, Conn., 1670-1710, 48 x 36½ / **$12,000** / est. $20,000-25,000 / dealer / 9-30 SPB.

204. Hadley chest, oak and pine, traces of red paint, restoration to top, Mass. or Conn., 1680-1710, 45¾ x 36 / **$17,000** / est. $15,000-20,000 / dealer / sold 6-77 Amherst, Mass., for $19,000; listed in Luther / 2-4 SPB.

205. Chest over drawer, oak and pine, retains most of original ebonized black decoration, top lacks cleats, eastern Mass., 1670-1710, 51¾ x 32 / **$17,000** / est. $7,500-10,000 / dealer / 4-29 SPB.

206. Chest over drawer (drawer missing), oak and pine, front painted green, rust and blue, eastern Mass., 1690-1710, 46½ x 31½ / **$50,000** / est. $10,000-12,000 / private / 4-29 SPB.

207. Chest with boxes inside (probably a carpenter's or ships' carpenter's), inside lid painted with flag, shield and eagle decoration, mid-19th c. / **$675** / dealer / 1-14 Skinner.

208. Chest, oak and pine, repairs to top and sides, probably eastern Mass., dated 1685, 53¼ x 31¼ / **$18,000** / est. $18,000-22,000 / dealer / provenance: Harry Arons, Antiques, Ansonia, Conn. / 9-30 SPB.

Furniture

209. Chest of drawers, old red finish, possibly Me., 1810-50 / **$175** / 9-14 Julia.

210. Chest of drawers, cherry, brasses replaced, New England, 1760-1800 / **$1,600** / 1-31 Phillips.

211. Chest of drawers, cherry, original brasses, feet pieced out about one inch, possibly New Hampshire, 1790-1815 / **$1,000** / dealer / 9-27 Brown.

212. Bow-front chest of drawers, mahogany veneer, original finish (top rubbed down), probably New England, circa 1800, 41½ x 41¾ / **$900** / 9-22 Garth's.

213. Chest of drawers, pine, original feet, repainted, New England, circa 1730, 36¾ x 39 / **$1,650** / 9-22 Garth's.

214. Bow-front chest of drawers, pine, paint decorated, brasses apparently original, New England, probably Mass., 1800-15, 41⅛ x 38¾ / **$2,300** / est. $1,200-1,500 / 11-18 SPB.

215. Chest of drawers, inlaid maple, old but replaced brasses, New England, 1790-1815 / **$2,800** / 4-21 Skinner.

216. Chest of drawers, birch, original red finish, original brasses, small repair to one foot, underside of drawers signed "J. Porter Crosby, November 30 1800" and "Porter," family history indicates origin as Portsmouth, N.H., 42¼ x 36 / **$2,300** / 5-5 Garth's.

Furniture

217. Serpentine-front chest of drawers, mahogany, repairs to one foot, New England, 1755-95, 40 x 33½ / **$4,200** / 9-29 FACP.

218. Chest of drawers, inlaid walnut, Virginia Piedmont, circa 1800, 36¾ x 41 / **$5,000** / 9-29 FACP.

219. Chest of drawers, inlaid cherry, original brasses, refinished, probably Penn., circa 1800, 38½ x 43 / **$3,150** / 10-13 Garth's.

220. Chest of drawers, cherry, original brasses, probably Conn., 1760-95, w. 29¾ / **$6,900** / 7-7 Withington.

221. Chest of drawers, walnut, original brasses, Philadelphia, 1755-95, 36¼ x 33½ / **$8,750** / est. $8,000-12,000 / 11-18 SPB.

222. Serpentine-front chest of drawers, cherry or apple, faded finish, Conn., probably Colchester area, circa 1780, 39 x 35¼ / **$11,000** / est. $8,000-12,000 / dealer / 2-4 SPB.

223. Oxbow-front chest of drawers, cherry, brasses old but not original, probably Penn. or Conn., 1755-95, w. 38/ **$7,000** / est. $7,000-9,000 / 9-22 Skinner.

224. Chest of drawers, tiger maple, brasses apparently original, branded on edges of top "T[heophilus]*Shove" and "Blrkley [sic]," Boston, circa 1760, 37¼ x 35 / **$10,000**/ est. $5,000-7,000 / private / 9-30 SPB.

Furniture

225. Block-front chest of drawers, walnut, Boston or Salem, Mass., 1740-60, 33½ x 30½ / **$16,500** / est. $20,000-25,000 / dealer / 4-29 SPB.

226. Chest of drawers, mahogany, original brasses, attributed to Jonathan Gostelowe, Philadelphia, circa 1770, 42 x 36 / **$18,000** / est. $10,000-15,000 / State Department / originally owned by Samuel Powel, mayor of Philadelphia in 1770's; exhibited Metropolitan Museum of Art, 1963 / 2-19 Sloan.

227. Block-front chest of drawers, mahogany, refinished, brasses apparently original, Boston area, 1755-95, 33 x 31½ / **$19,000** / est. $15,000-20,000 / dealer / 10-27 Skinner.

228. Block-front chest of drawers, mahogany, original brasses, probably Boston, 1760-95, 36¼ x 31¼ / **$14,000**/ est. $15,000-20,000 / provenance: Joe Kindig, York, Pa./ 2-4 SPB.

229. Block-front chest of drawers, walnut, original brasses, Boston area, 1755-95, 32½ x 31½ / **$36,000** / est. $25,000-30,000 / private / 10-27 Skinner.

230. Tall chest of drawers, maple, paint decorated, New England, 1760-95 / **$7,400** / 7-7 Withington.

231. Block-front chest of drawers, mahogany, original brasses, Boston area, 1760-80, 35½ x 32½ / **$57,500** / est. $25,000-35,000 / private / provenance: Israel Sack, Inc., N.Y. / 2-4 SPB.

232. Block-front chest of drawers, walnut, Boston, 1755-95, 35¾ x 29¾ / **$30,000** / est. $25,000-30,000 / private / 11-18 SPB.

Furniture

233. Tall chest of drawers, paint decorated, original brasses, New England, circa 1820 / **$2,000** / 1-14 Skinner.

234. Tall chest of drawers, birch, old finish, brasses apparently original, possibly Mass., circa 1790, 36 x 53½ / **$2,600** / est. $2,000-2,500 / 9-22 Skinner.

235. Chest on frame, walnut, Penn., 1755-95, 41 x 62¼ / **$3,500** / est. $3,000-4,000 / 11-18 SPB.

236. Tall chest of drawers, inlaid walnut, one back foot missing two inches of bracket, probably Penn., circa 1800, 41½ x 63 / **$7,000** / 7-28 Garth's.

Furniture

237. Linen press, mahogany veneer (minor chipping), interior has five sliding open-face drawers, finials missing, circa 1790 / **$1,700** / est. $1,000-1,500 / 11-24 Bourne.

239. Highboy, walnut, possibly Md. or southern, 1755-95, 40½ x 78 / **$3,750** / est. $7,500-9,000 / private / 10-31 Freeman.

238. Highboy, cherry, brasses original except for three escutcheons, possibly Penn. or N.J., 1755-95, 38½ x 74 / **$4,700** / est. $6,000-8,000/ 1-31 Phillips.

240. Highboy, tiger maple, upper case retains original brasses, Hartford, Conn., 1740-60, 38 x 70½ / **$6,000** ($6,600) / est. $8,000-10,000 / dealer / ex-coll. Roger Hovey, Hartford / 3-10 Christie's.

241. Highboy, cherry, probably Conn. or N.Y., 1755-1810, h. 72 / **$9,400** / 7-25 Withington.

Furniture

242. Highboy, tiger maple, refinished, original brasses, two backboards replaced, probably R.I., 1755-95 / **$9,500**/ provenance: Samaha Antiques, Ohio / 5-5 Garth's.

243. Highboy, walnut, Penn., 1755-95, 41 x 72 / **$10,000** ($11,000) / est. $8,000-12,000 / provenance: Israel Sack, Inc., N.Y. / 10-21 Christie's.

244. Highboy, walnut veneer, Mass., 1730-50, 38½ x 64 / **$12,000** ($13,200) / est. $12,000-15,000 / 10-21 Christie's.

245. Highboy, cherry, brasses apparently original, Conn. Valley, 1755-95, 42 x 89 / **$14,000** / est. $15,000-25,000 / 11-18 SPB.

Furniture

246. Highboy, maple, old finish, some cornice molding possibly replaced, probably New Hampshire, 1755-1810/ **$16,500** / dealer / 7-25 Withington.

247. Highboy, burl walnut veneer, original brasses, drawer interior signed "E. King" and "1736," Boston or Salem, Mass., circa 1736, 40¼ x 65½ / **$16,000** / est. $15,000-20,000 / dealer / sold 5-75 SPB for $14,000 / 2-4 SPB.

248. Highboy, crotch walnut veneer and maple, original brasses, concealed drawer beneath cornice, probably eastern Mass. or R.I., 1730-50, 37¾ x 69½ / **$19,000** / est. $15,000-25,000 / provenance: Harry Arons, Antiques, Ansonia, Conn. / 9-30 SPB.

249. Highboy, cherry, Conn., 1740-80, 41¼ x 89½ / **$19,000** / est. $20,000-25,000 / 11-18 SPB.

Furniture

250. Highboy, cherry, original brasses, attributed to Eliphalet Chapin, East Windsor, Conn., 1771-1807, 38¼ x 84 / **$35,000** (record for a Conn. highboy) / est. $30,000-$40,000 / 11-18 SPB.

251. Highboy, mahogany, retains most of original brasses, left rear leg restored, attributed to John Goddard, Newport, R.I., circa 1770, 39¾ x 82¾ / **$32,000**/ est. $40,000-60,000 / dealer / 11-18 SPB.

252-253. Highboy and matching lowboy, walnut veneer, original brasses, lowboy retains original finish, Salem, Mass., 1740-60, highboy 37½ x 81½, lowboy 33¼ x 31¼ / **$55,000** / est. $40,000-50,000 / private / provenance: the Dimon-Green families, Mass. / 4-29 SPB.

254. Highboy, maple, original brasses, old refinishing, probably southern New Hampshire, 18th century, 38 x 75⅝ / **$10,000** / est. $10,000-15,000 / dealer / 11-24 Bourne.

Furniture

255. Highboy base, cherry, attributed to the Dunlap workshop, N.H., 1768-1800 / **$5,000** / dealer / 7-25 Withington.

256. Spice chest, walnut, Philadelphia, 1755-95, 19½ x 46¼ / **$74,000** (record for a spice chest) / est. $25,000-35,000 / private / 11-18 SPB.

257. Lowboy, cherry, brasses apparently original, Conn., Woodbury area, 1740-60, 33 x 29¾ / **$7,500** / est. $4,000-6,000 / 9-30 SPB.

258. Lowboy, walnut, Delaware Valley, 1755-95, 33¼ x 29 / **$12,000** / est. $6,000-8,000 / dealer / 11-18 SPB.

259. Lowboy, crotch walnut veneer, original brasses, probably eastern Mass., 1730-50, 32 x 29½ / **$14,000** / est. $12,000-15,000 / private / provenance: Harry Arons, Antiques, Ansonia, Conn. / 4-29 SPB.

260. Lowboy, tiger maple, Philadelphia, 1755-95, 36 x 28½ / **$23,000** / est. $25,000-35,000 / 11-18 SPB.

261. Chest on chest, mahogany, Philadelphia area, 1755-95, 41½ x 79¾ / **$2,300** / est. $2,000-3,000 / dealer / provenance: Sarah Roberts collection, Wakefield, R.I. / 11-24 Bourne.

262. Lowboy, mahogany, attributed to William Wayne, Philadelphia, circa 1770, 34 x 32 / **$40,000** / est. $30,000-40,000 / dealer / 4-29 SPB.

Furniture

263. Chest on chest, cherry, original brasses, finials replaced, Conn., 1755-95 / **$9,000** / est. $12,000-15,000 / 10-27 Skinner.

264. Chest on chest, mahogany, probably Mass., 1755-95, 41 x 84 / **$11,000** ($12,100) / est. $12,000-15,000 / private / 10-21 Christie's.

265. Chest on chest, mahogany, fair condition, repair to upper portion of finial, Philadelphia, 1755-95, 46 x 99¼ / **$12,500** / est. $20,000-30,000 / illus. in Hornor, no. 102 / 11-18 SPB.

266. Chest on chest, flame birch, original brasses, possibly, N.H., 1760-1800, 40¼ x 82¼ / **$15,000** / est. $8,000-10,000 / private / 9-22 Skinner.

Furniture

267. Block-front chest on chest, mahogany, attributed to Benjamin Frothingham, Charlestown, Mass., circa 1770, 42 x 89 / **$35,000** ($38,500) / est. $25,000-35,000 / private / 10-21 Christie's.

268. Chest on chest, cherry, feet cut down, Conn., probably Colchester-Norwich area, 1755-95, 44½ x 89 / **$45,000** / est. $50,000-75,000 / dealer / provenance: the Marvin family, Conn. and Vt.; exhibited at Hartford, Conn, The Wadsworth Atheneum, 1976 / 9-30 SPB.

269. Slant-lid desk, cherry, New England, 1790-1820, 39¼ x 45¾ (writing h. 34⅝) / **$1,350** / 10-13 Garth's.

270. "Apothecary" desk, pine, probably New England, 19th c., w. 27 / **$1,200** / 7-25 Withington.

271. Desk, walnut, attributed to Thomas Affleck, Philadelphia, circa 1790 / **$1,200** / est. $750-1,000 / Independence Hall / probably the only surviving delegate's desk from Congress Hall, Philadelphia; "undercataloged" as "Hepplewhite bow-front mahogany serving table" / 1-31 Phillips.

Furniture

272. Slant-lid desk, maple, probably New England, probably 1740-60, w. 36 / **$3,600** / 7-25 Withington.

273. Oxbow-front slant-lid desk, cherry, Mass., 1755-95, 44¼ x 44 / **$3,500** ($3,850) / est. $4,000-6,000 / private / 10-21 Christie's.

274. Double tambour desk, mahogany, probably New England, circa 1800, w. 38½ / **$2,000** / est. $1,200-1,500 / 10-31 Freeman.

275. Slant-lid desk, inlaid cherry (exterior and interior), minor repairs to lid, minor foot damage, probably Penn., circa 1790, w. 39 / **$3,200** / est. $3,000-4,000 / 9-22 Skinner.

276. Slant-lid desk, tiger maple, early finish, some original escutcheons, New England, probably circa 1750, w. 35 / **$4,000** / dealer / 1-14 Skinner.

277. Cylinder-front desk, mahogany, Haines-Connelly school, Philadelphia, circa 1800, 42 x 42½ / **$4,250** / est. $5,000-7,000 / 11-18 SPB.

278. Slant-lid desk, maple, simple interior, minor repair to lid, New England, probably circa 1750, w. 35¾ / **$5,250**/ est. $4,000-5,000 / 9-22 Skinner.

279. Desk on frame, walnut, Penn., 1700-40, 32¾ x 33½ / **$5,500** / est. $7,000-10,000 / dealer / sold 1-77 SPB for $9,000 / 2-4 SPB.

Furniture

280. Slant-lid desk, tiger maple, all original, probably Mass., 1755-95, w. 33½ / **$9,000** / 7-7 Withington.

281. Slant-lid desk, walnut, slides have secret compartments, Penn., 1755-95, 43 x 44½ / **$5,500** ($6,050) / est. $6,000-8,000 / dealer / 10-21 Christie's.

282. Slant-lid desk, cherry, old finish, brasses replaced, probably Penn. or N.J., 1755-95 / **$7,000** / dealer / 9-27 Brown.

283. Slant-lid desk, mahogany, some restoration, attributed to Goddard-Townsend workshop, Newport, R.I., 1755-75, 40½ x 42 / **$7,000** ($7,700) / est. $3,500-5,000 / 10-21 Christie's.

284. Oxbow-front slant-lid desk, mahogany, brasses apparently original, attributed to Stone and Alexander, Boston, circa 1790, 42 x 45¾ / **$9,500** / est. $4,000-6,000 / provenance: the Whitman family, Boston and Henniker, N.H. / 4-29 SPB.

285. Block-front slant-lid desk, mahogany, blocked-and-fan-carved interior drawers, original brasses, Boston, 1755-95, 45 x 44 / **$16,500** / est. $15,000-25,000 / provenance: Metropolitan Museum of Art; ex-coll. Dr. Eugene Bolles / 3-10 Christie's.

286. Small desk on frame, cherry and chestnut, New England, circa 1750, 24¾ x 39½ / **$9,500** / est. $6,000-8,000 / private / illus. in Sack p. 141 / 9-30 SPB.

Furniture

287. Block-front kneehole desk or dressing table, mahogany, attributed to Goddard-Townsend workshop, Newport, R.I., 1765-75, 35½ x 33 / **$140,000** ($154,000) (record for single piece of American furniture) / est. $100,000-$150,000 / dealer / provenance: the Watts family, Newport / 10-21 Christie's.

288. Block-front kneehole desk or dressing table, mahogany, N.Y., 1755-95, 35 x 32 / **$17,000** ($18,700) / est. $20,000-25,000 / 10-21 Christie's.

289. "Apothecary" desk, pine, probably New England, 19th c. / **$2,600** / 7-25 Withington.

291. Secretary, inlaid mahogany, minor base repairs, Mass. or N.H., circa 1800 / **$2,100** / 4-21 Skinner.

290. Secretary, inlaid mahogany, minor roughness, New England, circa 1800 / **$2,300** / dealer / 6-24 Morrill.

Furniture

292. Secretary, cherry, original brasses, New England, circa 1800 / **$3,700** / est. $2,000-2,500 / 10-27 Skinner.

293. Secretary, walnut, long-leaf yellow pine and white oak, original brasses, interior drawer inscribed "Anthony Mason, July 1797, Made by Alfred Moss, 25 Dollars," possibly Virginia, 38¼ x 84 / **$3,500** / est. $4,500-6,500 / dealer / 2-19 Sloan.

294. Secretary, walnut, lid and finial replaced, Penn., 1755-95, 39¼ x 96 / **$7,000** / est. $12,000-15,000 / 11-18 SPB.

295. Secretary, maple, New England, 1755-95 / **$10,000** / est. $6,000-8,000 / 10-31 Freeman.

Furniture

296. Secretary, inlaid mahogany, bears label of Matthew Egerton, New Brunswick, N.J., circa 1800, 81½ x 100½ / **$8,000** ($8,800) / est. $8,000-10,000 / 10-21 Christie's.

297. Secretary, walnut, some late 18th c. repairs and reconstruction of lower case, feet replaced, New England, 1700-20, 33 x 70½ / **$9,500** / 9-29 FACP.

298. Secretary, tiger maple, probably Mass., 1755-95, 38 x 79 / **$12,000** ($13,200) / est. $15,000-20,000 / 3-10 Christie's.

299. Secretary, mahogany and feather birch veneer, possibly Mark Pitman, Salem, Mass., 1790-1815, 40¼ x 77 / **$8,000** / est. $6,000-8,000 / provenance: John S. Walton, Inc., Conn. / 4-29 SPB.

Furniture

300. Secretary, mahogany, Salem, Mass., 1755-95, 39 x 98 / **$25,000** / est. $30,000-35,000 / private / illus. in Hornor, no. 56 / 4-29 SPB.

301. Secretary, inlaid maple, retains most of original brasses, minor repairs to base, probably Long Island, circa 1760, 36½ x 77¼ / **$21,500** / est. $9,000-10,000 / dealer / 9-22 Skinner.

302. Serpentine-front secretary, inlaid walnut and cherry, signed on two interior drawers "made by Shearer Aug. 1801" and "made by me, John Shearer...in Martinsburgh [Martins-burg, W.Va.]," several other inscriptions, original brasses, 41 x 106 / **$40,000** / est. $30,000-40,000 / Museum of Early Southern Decorative Arts / 2-4 SPB.

303. Oxbow-front secretary, mahogany, attributed to John Hurd (inscribed "J. Hurd" on the top of desk section), Newburyport, Mass., circa 1770, 44½ x 96 / **$65,000 ($71,600)** / est. $30,000-40,000 / dealer / provenance: The Women's City Club of Boston / 10-21 Christie's.

Furniture

305. Secretary, inlaid cherry, restoration to cornice, attributed to Elijah Booth, Woodbury, Conn., circa 1780, 43 x 82¾ / **$30,000** / est. $30,000-40,000 / private / provenance: Israel Sack, Inc., N.Y.; exhibited Litchfield, Conn., Litchfield Historical Society, 1969 / 9-30 SPB.

304. Secretary, mahogany, original brasses, one original finial, minor restorations, probably Philadelphia, 1755-95, 41 x 104 / **$28,000** / est. $20,000-30,000 / dealer / 11-24 Bourne.

306. Cupboard, pine, original blue-gray paint, possibly New England, 19th c., 34½ x 87¾ / **$625** / 1-6 Garth's.

307. Cupboard, poplar, old red paint, probably Penn. or Ohio, early 19th c., 49 x 83 / **$2,000** / 10-13 Garth's.

Furniture

308. Cupboard, pine, original red, black, brown and blue paint decoration, old glass, original hardware, probably Penn. or Ohio, circa 1815, 55 x 82¼ / **$8,250** / 7-28 Garth's.

309. Cupboard, pine, original green paint, probably Penn., circa 1820, 49¼ x 71½ / **$3,000** / est. $1,500-2,500 / dealer / 2-4 SPB.

310. Cupboard, pine, painted red, possibly New England, probably late 18th c., 41¼ x 84½ / **$3,300** / est. $1,500-2,000 / 4-29 SPB.

311. Cupboard, inlaid cherry, possibly N.Y. or southern, 41½ x 97½ / **$8,000** ($8,800) / est. $2,500-3,500 / dealer / 10-21 Christie's.

Furniture

312. Corner cupboard, pine, N.J. or Penn., circa 1800, 50 x 84 / **$1,400** ($1,540) / est. $800-1,200 / 10-21 Christie's.

313. Architectural corner cupboard, pine, refinished, probably Penn. or Ohio, circa 1800, 39 x 78¾ / **$1,700** / 1-6 Garth's.

314. Corner cupboard, cherry, possibly Penn., circa 1830, h. 82 / **$2,100** / dealer / 9-27 Brown.

315. Corner cupboard, pine, minor repairs to cornice, hinges replaced, possibly Penn., early 19th c., 46 x 83 / **$1,700** / 7-28 Garth's.

Furniture

316. Corner cupboard, pine, paint decorated, probably Shenandoah Valley, Va., 1775-1800, 56½ x 96 / **$5,000** / est. $6,000-8,000 / 2-4 SPB.

317. Corner cupboard, inlaid walnut, North Carolina, 1790-1820, 47 x 101½ / **$5,000** / 9-29 FACP.

318. Wardrobe, mahogany veneer and brass, school of Duncan Phyfe or Charles Honore Lannuier, New York, circa 1815, 62½ x 96 / **$12,500** / est. $2,000-3,000 / dealer as agent for private collector / 11-18 SPB.

319. Hanging cupboard, walnut, Penn., probably Chester County, circa 1750, 26½ x 38½ / **$3,900**/ est. $3,000-5,000 / 2-4 SPB.

320. Lift-top dry sink, pine, paint decorated, probably New England, 19th c./ **$650** / 7-25 Withington.

Furniture

321. Bed, maple and pine, posts increased in height and tester added, New England, circa 1810, 55 x 78 / **$1,900** / est. $2,000-2,500 / 9-30 SPB.

322. Tester bed, cherry, probably New England, circa 1820 / **$1,700** / 7-25 Withington.

323. Tester bed, birch, probably New England, circa 1820 / **$1,900** / 7-25 Withington.

324. Pencil-post tester bed, cherry, New England, circa 1800, w. 41 x l. 78 x h. 83 / **$2,600** / est. $2,000-2,500 / 9-30 SPB.

325. Bed, mahogany, Philadelphia, 1755-95, 52 x 76 / **$4,000** ($4,400) / est. $6,000-8,000 / one of approximately eight known examples; illus. in Downs, no. 5 / 3-10 Christie's.

Furniture

326. Pencil-post press bed, maple and pine, painted red, New England, 1750-1800, l. 70 x h. 72, sold together with a turned maple trundle bed (not shown) / **$4,750** / est. $1,000-1,500 / dealer / 4-29 SPB.

327. Sleigh bed, mahogany and brass, labeled and branded by Charles Honore Lannuier, New York, circa 1815, l. 96 x w. 57¼ x h. 42½ / **$19,000** / est. $7,000-9,000 / dealer / originally belonged to Alfred Seton, partner of John Jacob Astor / 11-18 SPB.

328. Tall-case clock, cherry, New England, circa 1795 / $3,000 / 7-25 Withington.

329. Tall-case clock, pine, grain-painted, hands missing, wooden works (needing repair) by Silas Hoadley, Conn., early 19th c. / $1,700 / dealer / 6-24 Morrill.

330. Tall-case clock, walnut, southern, circa 1800, 13½ x 86 / $4,500 / 9-29 FACP.

Furniture

331. Tall-case clock, birch, attributed to Elisha Smith, Sanbornton, N.H., early 19th c. / **$2,400** / 7-25 Withington.

332. Tall-case clock, cherry, unsigned brass works, probably Penn., late 18th c. / **$4,250** / dealer / 6-24 Morrill.

333. Tall-case clock, inlaid mahogany, dial signed "Joakim Hill, Flemington, N.J." circa 1815, 18½ x 96½ / **$3,500** / est. $1,500-2,000 / 1-18 SPB.

334-335. Tall-case clock, maple, saddleboard branded "T.[imothy] Chandler," Concord, N.H., circa 1800 / **$7,100** / 7-25 Withington.

336. Tall-case clock, mahogany, original painted dial, brass works signed "George [H.] [K]illenshead Wood's Town [N.J.], No. 7," late 18th-early 19th c., h. 94¼ / **$4,300** / est. $3,000-5,000 / dealer / 11-24 Bourne.

337. Tall-case clock, cherry, silvered dial, possibly missing original feet, Daniel Burnap, Andover (Coventry), Conn., circa 1800, h. 92 / **$10,000** / est. $10,000-12,000 / 9-22 Skinner.

Furniture

339. Pillar-and-scroll clock, mahogany veneer, 30-hour wooden movement, labeled Norris & North, Torrington, Conn., early 19th c. / **$800** / 4-21 Skinner.

338. Tall-case clock, cherry, silvered dial with minute register, maker's name "Joseph Bulkley, Fairfield [Conn.]," date "1779," and "R. Sherwood," 17¾ x 81 / **$7,250**/ est. $4,000-6,000 / provenance: Harry Arons, Antiques, Ansonia, Conn.; illus in Hoopes, *Connecticut Clockmakers,* no. 46 / 9-30 SPB.

341. Tall-case clock, birch, old red grained paint with later red varnish, dial repainted, dated 1807, retains label of Frederic Wingate, Augusta, Maine / **$8,250** / private / 8-10 F.O. Bailey.

340. Hanging watch house, pine, probably southern N.H., (sold with Seth Thomas watch) / **$400** / dealer / 6-23 Morrill.

342. Pillar-and-scroll clock, mahogany veneer (slight damage), works changed, Mark Leavenworth, Waterbury, Conn., circa 1835, 16½ x 31½ / **$1,100** / est. $1,200-1,500 / 2-4 SPB.

343. Steeple clock, rosewood veneer (slight damage), New Haven Clock Co., 2nd half 19th c., 10 x 19¾ / **$325** / est. $150-200 / 2-4 SPB.

344. Pillar-and-scroll clock, mahogany veneer, Hugh Kearney & Co., Wolcottville, Conn., circa 1825, 16¾ x 29¾ / **$850** ($935) / est. $1,200-1,500 / dealer / 10-21 Christie's.

345. Double-steeple clock, mahogany veneer, Birge & Fuller, Bristol, Conn., circa 1835, 13⅝ x 26½ / **$950** / est. $1,500-2,000 / 11-18 SPB.

346. Shelf clock, inlaid mahogany, all original except finials replaced, suspension spring broken, dial signed "Nathan Adams," Mass., circa 1800, h. 44¾ / **$12,000** / est. $9,000-12,000 / 6-6 Bourne.

Furniture

347. Lighthouse clock, mahogany and brass, lower brass collar and base sheared off in back, dial inscribed "Simon Willard & Son, Patent No. 152," Roxbury, Mass., circa 1825, h. 26½ / **$15,000** / est. $15,000-20,000 / exhibited at Old Sturbridge Village, 1971-77 / 2-4 SPB.

348. Banjo clock, mahogany, restorations, Aaron Willard, Boston, circa 1830, 10 x 29 / **$2,600** / est. $1,500-2,000 / dealer / 9-30 SPB.

349. Shelf clock, inlaid mahogany and brass, one foot replaced, David Wood, Newburyport, Mass., circa 1800, 20¾ x 24⅛ / **$13,000** / est. $8,000-12,000 / dealer / provenance: Harry Arons, Antiques, Ansonia, Conn. / 9-30 SPB.

350. Miniature highboy, curly walnut, retains most of original brasses, paper affixed to backboard reads "This chest was made for Sarah Pleasants in about the year 1780 [?]," Philadelphia, 1750-80, 26¾ x 52¾ / **$65,000** (record) / est. $20,000-25,000 / private / illus. in Hornor, no. 61 / 4-29 SPB.

351. Miniature slant-lid desk, maple, walnut and pine, untouched condition, original brasses, lid hinges early replacements, interior drawers missing, New England, 1700-40, 19 x 21½ / **$17,000** (record; but see fig. 350, sold at later date) / est. $5,000 / dealer / 3-11 Mooers.

353. Miniature chest, walnut, Penn., probably Chester County, 1760-80, 18½ x 10½ / **$2,300** / est. $1,500-2,000/ private / 2-4 SPB.

352. Bible box, pine, probably eastern Mass., dated 1685, l. 28½ / **$3,250** / est. $2,000-3,000 / dealer / 9-30 SPB.

Furniture

354. Box, pine, paint decorated, attributed to John Penniman, Boston, circa 1800, 18 x 9 / **$780** ($858) / est. $1,200-1,500 / provenance: John S. Walton, Inc., N.Y. / 3-10 Christie's.

355. Cutlery box, cherry, possibly Penn., 1790-1820, 14 x 10 / **$280** ($308) / est. $300-400 / 3-10 Christie's.

356. Bible box, oak and pine, probably Conn. Valley, circa 1690, 26¼ x 8½ / **$5,500** / est. $5,000-7,000 / dealer / provenance: Harry Arons, Antiques, Ansonia, Conn. / 9-30 SPB.

357. Candle box, painted blue-green, sliding cover initialed and dated in paint "R.N.S. 1773," l. 13¾ / **$600** / est. $250-350 / 9-30 SPB.

358. Pipe box, walnut, New England, 18th c., 5¼ x 17½ / **$1,500** / est. $1,000-1,500 / 9-30 SPB.

359. Pipe box, painted black with gold stringing, probably New England, probably 18th c., h. 24 / **$3,100** / est. $1,500-2,000 / 10-27 Skinner.

360. Pipe box, walnut, faint inscription "Made by M.A. _____, 1884," 6 x 19¼ / **$400** / est. $600-800 / 9-9 SPB.

Furniture

361. Hanging boxes, pine. Left to right: **$200; $375;** pipe box / **$700; $270** / 7-25 Withington.

362. Hanging boxes, 18th-19th c. Left to right, top to bottom: wall box, maple and pine, simulated third drawer, old red paint / **$275**; candle box, pine wood-hinge lid / **$225**; pipe box, cherry / **$625**; wall box, pine, old red paint ; **$200**; candle box, pine, traces of red paint / **$175**; knife scrub box, pine / **$80**; wall box, pine, old red paint / **$35** / 4-21 Skinner.

363. Hanging wall boxes, pine, old paint, probably 18th c. Left to right: one drawer, dovetailed / **$650**; hinged lid, rough condition / **$350**; double well / **$600** / 7-25 Withington.

364. Corner sconce, pine, painted red, probably New England, probably 18th c., 11 x 17½ / **$1,000** / est. $600-800 / 4-29 SPB.

365. Apothecary chest, pine, early 19th c., 35¼ x 40 / **$1,000** / est. $400-600 / dealer / 9-9 SPB.

Furniture

366. Pianoforte, inlaid mahogany, John Geib & Son, N.Y., circa 1790, l. 65½ x h. 34¼ / **$3,250** / est. $1,500-2,500 / 2-3 SPB.

367. Box, inlaid walnut, possibly Penn., late 18th-early 19th c. / **$1,250** / dealer / 8-10 F.O. Bailey.

368. Mirror, cherry and brass, circa 1820, 21 x 38½ / **$175** / est $100-150 / 10-27 Skinner.

369. Mirror, inlaid cherry, retains partial label of Samuel Noyes, East Sudbury, Mass., circa 1780 / **$500** / est. $400-500 / 10-27 Skinner.

370. "Courting" mirror, Continental (made for American market), late 18th-early 19th c., 7 x 11½ / **$700** / est. $600-700 / 10-27 Skinner.

371. Dressing mirror, inlaid mahogany, original brasses, maker's label reads "James C Kinnie, Joiner and Cabinatmaker [sic], Monticello, New York," 1800-15 / **$800** ($880) / est. $800-1,200 / provenance: Harry Arons, Antiques, Ansonia, Conn. / 3-10 Christie's.

Furniture

372. Mirror frame, pine, old green paint, probably New England, circa 1750 (with 19th c. silhouette) / **$1,100** / 7-25 Withington.

373. Mirror, walnut, all original, probably New England, 1740-60, 14 x 36½ / **$1,600** / est. $1,200-1,500 / dealer / 10-27 Skinner.

374. Mirror, walnut, 1740-60, 14 x 33½ / **$1,250** / est. $800-1,000 / 10-27 Skinner.

375. Mirror, gilt softwood, reverse painted tablet, circa 1800, with label of Cermenati and Bernarda (Boston)/ **$625** / dealer / 8-10 F.O. Bailey.

376. Mirror, walnut, circa 1750, 24 x 62 / **$1,600** / est. $4,000-5,000 / 10-27 Skinner.

377. Mirror, walnut, original glass cracked lower left, Philadelphia, circa 1770, 22 x 49½ / **$2,000** / est. $2,000-3,000 / 10-27 Skinner.

378. Mirror, walnut veneer, etched decoration, crest missing, otherwise apparently all original, 1700-40, 18 x 42½ / *$2,800* / est. $3,000-4,000 / dealer / 10-27 Skinner.

379. Mirror, inlaid and gilt mahogany, New York, 1790-1800, 22¾ x 54 / **$5,000** / est. $5,000-7,000 / provenance: Israel Sack, Inc., N.Y. / 2-4 SPB.

380. Mirror, walnut, probably New England, 1740-60, 15½ x 39½ / **$2,800** / est. $1,200-1,500 / 10-27 Skinner.

Pictures

381-382. Pair of portraits, oil on canvas, rough condition, remounted on late 19th c. stretchers, inscribed on reverse: "The Portrait of Mr. Christopher Forehand aged 47 years painted by Mrs. [R.W.] Shute Dec. 14, 1833," and "The Portrait of Betsy Forehand aged 35 years painted by Mrs. Shute Nov. 26, 1833," each 26 x 23 / **$4,500** / est. $10,000-12,000 / 5-11 Skinner.

383. Portrait of Gideon G. Varney, watercolor on paper, Joseph H. Davis, N.H., dated 1833, 5¾ x 7¼ / **$4,600** / est. $3,000-4,000 / dealer / exhibited 1974-75: The Art Institute, Chicago, The Art Museum, St. Louis, Williamsburg, the Currier Gallery, Manchester, N.H.; ex-coll. Garbisch / 4-27 SPB.

384. Portrait of lady and child on yellow Windsor rocker, watercolor on paper, dark blue dress, child's dress rust color, 10½ x 8 / **$2,900** / 10-30 Pennypacker.

Pictures | 149

385, 386, 387 388. Portraits of members of the Arnold family, Arnoldsville, R.I., watercolor on paper, Joseph A. Davis, R.I. Left to right, top to bottom: Captain Edward G. Arnold, dated Jan. 26, 1848, 5⅝ x 6⅞ / **$2,250** / est. $1,000-1,500; Mrs. Almariah Arnold, dated Jan. 25, 1848, 5⅞ x 7⅛ / **$1,900** / est. $1,000-1,500; Emma L. Arnold, initialed "J.A.D.," dated Jan. 26, 1848, 5¼ x 6⅞ / **$4,800** / est. $1,500-2,000; man of Arnold family, circa 1848, 5¼ x 6⅞ / **$850** / est. $800-1,200 / exhibited 1974-75: The Art Institute, Chicago, The Art Museum, St. Louis, Williamsburg, the Currier Gallery, Manchester, N.H.; ex-coll. Garbisch / 4-27 SPB.

389. Marriage record and portrait of Jacob Schock, watercolor on paper, Jacob Maentel, Lebanon County, Penn., dated 1833, 9¼ x 11½ / **$5,000** / est. $8,000-10,000 / 2-1 SPB.

390. Marriage record and portrait of Elizabeth Illig Schock (sold with the *taufschein* of Schock and of her first child and the black lace collar in which subject was painted on her wedding day, not shown), watercolor on paper, Jacob Maentel, Lebanon County, Penn., dated 1833 / **$6,000** / est. $8,000-10,000 / provenance: the family of Jacob and Elizabeth Schock / 2-1 SPB.

391. Portrait of a man, watercolor on board, attributed to R.W. and S.A. Shute, probably Mass. or N.H., circa 1840, 19¼ x 26 / **$6,500** / est. $1,500-2,000 / dealer / 2-1 SPB.

392. Portrait of Moses Kimball, Jr., oil on canvas, William Jennys, circa 1790, 25 x 30¼ / **$9,000** / est. $8,000-12,000 / 9-30 SPB.

393. Portrait of a boy (possibly Samuel Field McIntire II), oil on canvas, 19th c., 32¼ x 53¾ / **$13,000** ($14,300) / est. $2,000-3,000 / dealer/ 10-21 Christie's.

394. Portrait of a man, watercolor on paper, indistinctly signed "James N. Sinter [?]," dated 1810, 14 x 19 / **$17,750** / est. $2,000-2,500 / ex-coll. Garbisch / 4-27 SPB.

395. Portrait of two boys, oil on canvas, 19th c., 28 x 34 / **$17,000** / est. $7,000-9,000 / private / 2-1 SPB.

396. Portrait of President William Henry Harrison, oil on canvas, inscribed on reverse "Original portrait of Gen. Wm. Harrison painted at Cincinnati, O. Oct. 1835 by J.R. Lambdin," 25 x 30 / **$15,000** / est. $1,000-1,500 / private / original of all engravings of President Harrison; "undercataloged" as "General William Harrison" / 2-3 SPB.

397. Portrait of William and Henry Low, oil on canvas, circa 1828, 45 x 51 / **$19,000** / est. $3,000-5,000 / 11-17 SPB.

398. Portrait of a boy, watercolor and pencil on paper, attributed to R.W. and S.A. Shute, probably Mass., circa 1840, 18½ x 27¼ / **$42,500** (record for an American folk watercolor) / est. $8,000-12,000 / private / ex-coll. Garbisch / 4-27 SPB.

399. Pair of portraits of Henry Foxhall and his wife, crayon on paper, original mats and frames, Charles Balthazar Fevret de St.-Memin, Va., circa 1805, 21½ x 15½ / **$14,500** / est. $12,000-15,000 / listed in Dexter, *The St.-Memin Collection of Portraits*; registered in the Frick Art Reference Library, no. 13813; exhibited Virginia Museum of Fine Arts, Richmond; Foxhall was a personal friend of Jefferson's and Francis Scott Keyes's / 2-4 SPB.

Pictures 153

400. Painting of the Brown Homestead, Hamburg, Conn., oil on canvas, 19th c., 48½ x 34¼ / **$7,250** / est. $700-1,200 / 2-3 SPB.

401. Painting of farmyard scene, oil on canvas, one small tear, probably Ohio, 19th c., 29¾ x 23 / **$1,025** / 4-7 Garth's.

402. Painting of "Uncatena Island Off Woods Hole," oil on canvas, signed "C.S. Raleigh, 1905," 20¼ x 16¼ / **$1,250** / est. $3,000-5,000 / 8-2 Bourne.

403. Portrait of the schooner *Nellie* of Calais, Maine, oil on canvas, needs restoration, signed "[W.P.] Stubbs," circa 1870, 30 x 19¾ / **$950** / est. $1,000-1,500 / 10-27 Skinner.

404. Portrait of the steamsailor *Abana*, oil on canvas, signed."A.[ntonio] Jacobsen," dated 1894, 36 x 22 / **$2,500** /est. $1,500-2,500 / 2-3 SPB.

Pictures

405, 406, 407 408. Four portraits of a man, a woman, and their two children, oil on board, William Matthew Prior (1806-73), 13½ x 17½ / **$13,000** / est. $7,000-10,000 / 11-17 SPB.

409. Painting of "Innocence with the Unicorn and the Lion," watercolor on paper, Eunice Pinney, Conn., circa 1810, 11¾ x 9¼ / **$2,700** / est. $1,000-1,500 / exhibited The National Gallery, 1953-73; ex-coll. Garbisch / 4-27 SPB.

410. Painting, watercolor on paper, Eunice Pinney, Conn., circa 1815, 15 x 12½ / **$4,500** / est. $3,000-5,000 / private / ex-coll. Garbisch; exhibited the Antiquarian Society, Plymouth, Mass., 1976, and the Museum of American Folk Art, N.Y., 1969; painted on the back of a letter to the artist's niece, Emiline M. Pinney / 4-27 SPB.

Pictures

411. Portrait of the "Bark Rainbow, Cap' George Gray, Off Dumplin Light—Bound In," watercolor, slight fading and foxing, signed "[Benjamin] Russel" (1804-1885), 37 x 24 / **$6,000** / est. $10,000-15,000 / 8-2 Bourne.

412. Painting of "America's Cup Races off Sandy Hook," watercolor (sold with a chromolithograph after this painting), signed "F.[rederick] S. Cozzens," dated 1881, 32 x 18¾ / **$5,250** / est. $2,500-3,500 / 2-19 Sloan.

413. Portrait of the schooner *Cephas Starrett*, oil on canvas, signed "J.C. Babbidge, Apr. 1877. No. 8," 36¼ x 23 / **$3,000** / est. $2,500-3,500 / private / ex-coll. Arthur J. Sussel, Philadelphia / 2-19 Sloan.

414. Portrait of the sailing ship *James W. Fitch*, oil on canvas, signed "W.P. Stubbs," circa 1870, 43 x 28 / **$2,100** / est. $1,500-2,000 / 9-22 Skinner.

415. Portrait of "The Three-masted schooner 'Elisha Gibbs' Off Gay Head, Martha's Vineyard," oil on canvas, signed "C.S. Raleigh, 1880," 40¼ x 27½ / **$6,750** / est. $6,000-9,000 / 8-2 Bourne.

416. Portrait of the *U.S.S. Constitution*, oil on canvas, attributed to Joseph B. Smith (1798-1876), 29¼ x 20¼ / **$8,200** / est. $7,500-10,000 / ex-coll. Arthur J. Sussel, Philadelphia / 2-19 Sloan.

417. Portrait of the clipper ship *Flying Dutchman*, oil on canvas, signed "[William] Marsh," dated 1853, 42 x 30⅛ / **$8,250** / est. $10,000-15,000 / ex-coll. Arthur J. Sussel, Philadelphia / 2-19 Sloan.

418. Portrait of the barque *Braziliro*, oil on canvas, inscribed on reverse "Bark Braziliro 2.31 tons, 1851 New York Vera Cruz Line, Charles Marsh Master, P. Hargans & Co. agents, 33 South St. NYC, D. McFarlane," 36 x 24 / **$11,500** / est. $7,500-10,000 / 2-3 SPB.

419. Portrait of the *Monarch of the Seas*, oil on canvas, signed "D. McFarlane 1863," 36¼ x 24½ / **$16,000** / est. $12,000-18,000 / ship was built in 1854, home port New York; provenance: Child's Gallery, Boston / 8-2 Bourne.

Pictures

420. Theorem painting, oil on velvet, early 19th c., 17 x 14½ / **$425** / est. $350-400 / 9-22 Skinner.

421. Theorem painting, oil on velvet, Nancy Chace, early 19th c., 20½ x 17½ / **$900** / est. $600-800 / provenance: the L.P. Blood Homestead, Pepperell, Mass. / 9-22 Skinner.

422. Still life, oil on canvas, original painted frame, probably New England, 19th c. / **$1,600** / 1-14 Skinner.

423. Theorem painting, watercolor on velvet, 19th c., 15¾ x 13½ / **$650** / est. $1,000-1,500 / private / 2-1 SPB.

424. Fire-screen painting, oil on canvas, rebacked and small restorations, medallion on urn inscribed "H.F.S. 1843," 42 x 37 / **$1,650** / provenance: Kennedy Galleries, N.Y. / 5-5 Garth's.

425. Fraktur, birth and baptismal record of Maria Walbert, red, yellow and green watercolor on paper, the Flying Angel Artist, Berks County, Penn., dated 1803, 16½ x 13¼ / **$600** / est. $800-1,200 / dealer / 2-1 SPB.

426. Fraktur, bookplate of Levi Meyer, red, yellow, blue, and green watercolor on paper, Penn., dated 1835, 4 x 6¾ / **$650** / est. $400-600 / 2-1 SPB.

427. Fraktur, yellow, red, and blue watercolor on paper, attributed to the "House Segen" artist, dated 1828, Penn., / **$1,800** / 10-30 Pennypacker.

Pictures

428. Calligraphic picture of a fish, signed "Orin Couch," possibly New England, 19th c. / **$225** / est. $100-125 / private / 10-27 Skinner.

429. Fraktur, yellow border, watercolor on paper, Penn., early 19th c., 12 x 15 / **$2,900** / 4-4 Pennypacker.

430. Pair of calligraphic pictures (one shown), red, green, yellow, blue, and brown watercolor on blue paper, Marlboro, Vt., dated March 15, 1855, 7⅝ x 9¾ / **$425** / est. $700-1,000 / 2-1 SPB.

431. Shaker spiritual drawing of the "Mechanical view of the faculties of the soul," watercolor on paper, signed "PP," circa 1810, 21¼ x 15½ / **$1,200** / est. $700-1,000 / ex-coll. Garbisch / 4-27 SPB.

432. Memorial picture, oil on velvet, probably New York, 19th c., 25½ x 22½ / **$1,000** / est. $600-800 / private / 2-1 SPB.

433. Sign, painted pine, 19th c. / **$1,900** / 7-7 Withington.

434. Sign, pine, painted similarly on both sides, wrought-iron hooks, 19th c., 40¾ x 28¼ / **$2,750** / est. $800-1,200 / 2-1 SPB.

435. Political banner, oil on canvas, reverse reads "Lincoln and Hamlin Sure in November For Justice Shall Triumph," some tears and stains, Maine 1860, 24 x 36 / **$1,150** / dealer / 9-14 Julia.

436. Lithograph of "Life in the Woods. Returning to Camp," hand colored, slight discoloration and staining, repaired tear, small restorations, lower publication line, published by Currier and Ives, N.Y. 1860, 27½ x 11¾ / **$1,000** / est. $700-900 / 2-3 SPB.

437. Lithograph of "The Celebrated Trotting Mare Hattie Woodward," hand colored, good condition, lower publication line, after France & Gates, St. Louis, published by Currier and Ives, N.Y. 1881, 27¾ x 18½ / **$900** / est. $400-600 / 11-17 SPB.

438. Set of hollow-cut silhouettes of the Adams family (John, Abigail, John Quincy and Louisa Catherine), all inscribed with the names of the sitters, two embossed "Peale" (Peale's Museum), Henry Williams, dated "1 August 1809" in John Quincy Adams's hand, 10¼ x 12⅛ overall / **$3,250** / est. $5,000-7,000 / exhibited The National Portrait Gallery, 1970-71 / 11-17 SPB.

439. Lithograph of "The 'Lightning Express' Trains. Leaving the Junction," hand colored, several repaired tears, surface scratches, and waterstains, lower publication line, after F.F. Palmer, 1863, published by Currier and Ives, N.Y., 28 x 18⅛ / **$1,600** / est. $2,000-2,500 / 11-17 SPB.

440. Lithograph of "The 'Lightning Express' Trains. Leaving the Junction," hand colored, bright impression, slight discoloration, lower publication line, after F.F. Palmer, 1863, published by Currier and Ives, N.Y., 27⅞ x 17¾ / **$6,200** / est. $2,800-3,400 / 2-3 SPB.

Pictures

441. Lithograph of "Early Winter," hand colored, a few repaired tears, waterstaining on bottom margin, publication line, published by Currier and Ives, N.Y., 1869, 9⅝ x 17 / **$1,300** / est. $500-800 / 11-17 SPB.

442. Lithograph of "The Farmers Home—Winter," printed in color, fresh impression, slight discoloration and staining, lower publication line, after G.H. Durrie, 1863, published by Currier and Ives, N.Y., 23¾ x 16⅜ / **$2,200** / est. $1,400-1,800 / 2-3 SPB.

443. Line engraving of "The Bloody Massacre Perpetrated in King Street, Boston, on March 5th, 1770 . . .," hand colored, signed in print "Engrav'd Printed & Sold by Paul Revere Boston," second state, some tears and abrasions, trimmed just outside platemark along the sides, 9⅛ x 10½ / **$3,250** / est. $4,000-6,000 / private / 2-3 SPB.

444. Mezzotint of "The Hon.ble John Hancock. of Boston in New-England...," after Littleford, published by C. Shepherd, London, 1775, minor damage, 9¼ x 14⅛ / **$750** / est. $250-350/ 2-3 SPB.

445. Engraving and aquatint of the "Long-billed Curlew" (plate CCXXXI), creases and small tears affecting edges of the subject, trimmed just inside the platemark, R. Havell after John James Audubon, London, 1834, 36½ x 24½ / **$2,200** / est. $1,400-1,800 / 11-17 SPB.

446. Engraving and aquatint of the "Goosander" (plate CCCXXXI), hand colored on J. Whatman paper with 1838 watermark, slight discoloration and foxing, tears (one running into subject), margins trimmed within the platemark, R. Havell after John James Audubon, London, 1836, 37¼ x 25 / **$1,700** / est. $1,000-1,400 / ex-coll. Mrs. Seward Webb Pulitzer; sold 9-72 SPB for $850 / 2-3 SPB.

447. Engraving and aquatint of the "Blue Crane, or Heron" (plate CCCVII), hand colored on J. Whatman paper with 1836 watermark, slight discoloration and foxing, small tear, tiny scrape in subject, full margins, R. Havell after John James Audubon, London, 1836, 33⅛ x 24⅜ / **$3,700** / est. $2,500-3,000 / ex-coll. Mrs. Seward Webb Pulitzer; sold 9-72 SPB for $2,300 / 2-3 SPB.

Ceramics and Glass

448. Redware spaniel, cream-yellow paint, details in black sponge- and brush-work, stamped "John Bell, Waynesboro, Pennsylvania," mid-19th c., h. 9 / **$1,000** / est. $1,500-2,500 / dealer / ex-coll. Wiltshire; illus. in Wiltshire, no. 5; exhibited Williamsburg, 1975 / 2-1 SPB.

449. Redware spaniel, streaky brown glaze, stamped "John Bell, Waynesboro, Pennsylvania," late 19th c., h. 9 / **$700** / est. $800-1,200 / dealer / ex-coll. Wiltshire; illus. in Wiltshire, no. 5; exhibited at Williamsburg, 1975 / 2-1 SPB.

450. Redware lion, yellow glaze, probably Penn., mid 19th c. / **$300** / 10-30 Pennypacker.

451. Redware dog, seated with basket in mouth, handles missing from basket / **$150** / 10-30 Pennypacker.

Ceramics and Glass

452. Pottery whippet, semimatte black glaze, signed on underside "Solomon Bell, Winchester, Virginia," early 19th c., 10 x 6¾ / **$3,250** / est. $2,000-2,500 / private / ex-coll. Wiltshire; illus. in Wiltshire, no. 8; exhibited Williamsburg, 1975 / 2-1 SPB.

453. Redware lamb, cream, green, and brown glaze, S. Bell & Son, Strasburg, Va., late 19th c., 12 x 3½ / **$1,750** / est. $2,500-3,500 / private / ex-coll. Wiltshire; illus. in Wiltshire, no. 27; exhibited Williamsburg, 1975 / 2-1 SPB.

454. Redware figural group, in three separate parts, front part with well and potter's mark missing, inscribed "From Fisher's Hill, Battle Fields, Sept. 1864," Eberly Potters, Strasburg, Va., 1894, 15⅛ x 15¼ / **$2,500** / est. $2,000-3,000 / Smithsonian Institution / ex-coll. Wiltshire; illus. in Wiltshire, no. 40; exhibited Williamsburg, 1975; one of two made by Levi Begerly and Theodore Fleet / 2-1 SPB.

455. Redware poodle, green and brown glaze, probably Penn., mid-19th c., h. 11 / **$825** / 10-30 Pennypacker.

456. Redware, 19th c. Left to right: fluted mold, mottled brown glaze, stamped "John Bell," Waynesboro, Penn., dia. 4¼ x h. 2¼ / **$180**; spaniel, black glaze, attrib. to John Bell, h. 12½ / **$300**; pitcher, mottled brown glaze, spout partially broken, some chips, stamped "John Bell, Waynesboro," h. 5½ / **$120** / 7-22 Kinzle.

457. Redware lion, yellow and brown glaze, John Bell, Waynesboro, Penn., mid-19th c., 8½ x 7½ / **$18,000** (record for American redware) / est. $12,500-15,000 / private / ex-coll. Wiltshire; illus. in Wiltshire, no. 2; exhibited Williamsburg, 1975; one of four known / 2-1 SPB.

458. Redware pitcher, green and brown glaze, some glaze wear, handle chipped, 19th c., h. 3¾ / **$155** / 3-17 Garth's.

459. Redware flower urns, 19th c. Left to right: Shenandoah glaze, lion's-head handles, rough condition, dia. 10 x h. 15 / **$130**; mottled brown-green Shenandoah glaze, base and rim chips, attributed to George Schweinfurt, New Market, Va. dia. 7 x h. 9¼ / **$70** / 7-22 Kinzle.

Ceramics and Glass

460. Pottery, 19th c. Left to right: redware jar, cream, green, and brown glaze, stamped "S. Bell & Son, Strasburg," Va., dia. 5¼ x h. 6 / **$140**; animal whimsy, cream, green and brown Shenandoah glaze, 4 x 5 / **$105**; redware, flower pot, attached saucer, yellow and brown glaze, rim and saucer chips, dia. 4½ x h. 4 / **$35**; miniature pitcher, dark green glaze, h. 1¾ / **$20**; redware flower pot, attached saucer, brown glaze, yellow sgraffito decoration, attributed to Anderson, dia. 8 x h. 7 / **$220** / 7-22 Kinzle.

461. Redware bank, brown glaze, yellow and brown decoration, some damage to birds, attributed to Remmey, 19th c. / **$130** / sold 1975 Kinzle for $110 / 7-22 Kinzle.

462. Two redware flower pots, red-orange and black glaze and orange-red and green glaze, attached saucer, chips, New England, 19th c., h. 6¾ and 4¾ / **$325** / est. $300-350 / dealer / 4-29 SPB.

463. Pottery, 19th c. Left to right, top to bottom: redware light stand, shiny black glaze, flaked, h. 3½ / **$20**; redware dog holding basket, open front legs, cream slip and greenish-brown glaze, h. 4 / **$230**; redware bank, Shenandoah cream, brown, and green glaze, h. 4¼ / **$435**; redware candle holder, Shenandoah cream and brown glaze, McKearin sale sticker no. 596, h. 1¾ / **$435**; Bennington white clay two-piece bank, brownish-red glaze, minor edge flakes, McKearin no. 390, dia. 3¼ x h. 2⅜ / **$65**; frog inkwell, blue and gray glaze, base incised "Anna Pottery 1882," Lowell, Ill., h. 3¼ / **$355**; woman's-head inkwell, brown glaze, McKearin no. 807, l. 2½ / **$25**; smiling-man inkwell, brown glaze, McKearin no. A-72, l. 3 / **$42.50**; crimped salt, Shenandoah cream and dark green glaze, McKearin no. 623, h. 2¾ / **$290**; redware cradle, end incised "Baby--June 4," clear glaze, l. 4½ / **$122.50** / ex-coll. Hoffman; beehive bank, black glaze, h. 2⅞ / **$35**; redware inkwell, pheasant finial, dia. 3¼ x h. 3½ / **$435** / ex-coll. Hoffman; redware warmer, cream, green, and clear glaze, North Carolina, dia. 4 x h. 2¼ / **$175**; sewer tile frog, base incised "Made by John H. Crosby, Brazil, Ind.," h. 3 / **$127.50**; lion window stop, brown glaze, minor flakes, h. 3½ / **$75** / 5-5 Garth's.

Ceramics and Glass

464. Redware trays, slip decorated, 19th c. Left to right: chips, wear, possibly Cape Cod or Long Island, 12¼ x 8¾ / **$325** / est. $250-350; probably New England, 16¾ x 11½ / **$425** / est. $250-350; two pieces (the one not shown with interlacing S motifs), probably Conn., 11 x 7¾ and 13 x 9 / **$550** / est. $300-400 / 4-29 SPB.

465. Set of three nesting redware bowls, clear glaze with black brush strokes, New England, 19th c., dia. 10 to 12 x h. 3 to 4½ / **$350** / est. $150-200 / 4-29 SPB.

466. Redware flower pot and matching saucer, mocha style tree decoration, marked "John Bell, Waynesboro," Penn., mid 19th c. / **$680** / 10-30 Pennypacker.

467. Redware, 19th c. Left to right: pitcher, green Shenandoah glaze, base and rim chips, attributed to Bell, h. 9 / **$110**; turk's-head mold, mottled brown glaze, stamped "John Bell, Waynesboro," Penn., dia. 10 x h. 5½ / **$370** / 7-22 Kinzle.

468. Redware fruit bowl yellow glaze and sgraffito decoration, pine tree center and date "1815," probably Penn., dia. 10½ / **$725** / 10-30 Pennypacker.

469. Redware plate, slip decorated, rim chips, some wear, probably Conn., 19th c., dia. 12 / **$700** / est. $400-500 / dealer / 4-29 SPB.

470. Redware plates, yellow slip decoration, New England, 19th c. / ex-coll. Pennypacker. Left to right: dia. 9⅛ / **$850**/ est. $300-500; dia. 9⅛ / **$475** / est. $300-500 / 2-1 SPB.

Ceramics and Glass

471. Pottery inkwell with quill holders, Shenandoah glaze, bird finial, flowers, dog holding inkpot, attributed to S. Bell, 10½ x 5½ / **$800** / 7-22 Kinzle.

472. Redware wash bowl and pitcher, cream-yellow, green and brown glaze, some chips, S. Bell & Son, Strasburg, Va., late 19th c., bowl dia. 14½ x h. 7, pitcher h. 11¾ / **$1,000** / est. $1,000-1,500 / dealer / ex-coll. Wiltshire; illus. in Wiltshire, no. 33; exhibited Williamsburg, 1975 / 2-1 SPB.

473. Two redware plates (one shown), slip decorated, inscribed "William & Mary" and "Mary's Dish" (not shown), chips and wear, Conn. or Long Island, dia. 11 and 12½ / **$950** / est. $400-500 / dealer / 4-29 SPB.

474. Redware plate, sgrafitto decoration, yellow and green glaze, Penn., early 19th c., dia. 11¼ / **$5,750** / est. $5,000-7,000 / dealer / ex-coll. Pennypacker / 2-1 SPB.

475. Redware plates, slip decorated, 19th c. Left to right: minor rim chips, probably New England, dia. 12 / **$1,700** / est. $400-600; some rim chips, probably New England, dia. 14 / **$550** / est. $300-500; some rim chips, probably New England or Long Island, dia. 12 / **$1,700** / est. $300-500 / 4-29 SPB.

476. Redware plate, yellow and green glaze with stenciled decoration, signed "Conrad K. Raininger," Montgomery County, Penn., dated "June the 23, 1838," dia. 9⅝ / **$8,250** / est. $6,000-8,000 / private / ex-coll. Pennypacker / 2-1 SPB.

477. Stoneware, 19th c. Left to right: crock, blue stencil "A. Conrad, New Geneva, Pa., 2," rim chip, dia. 6¾ x h. 11¾ / **$40**; canning jar, blue stencil "A. Conrad & Co., New Geneva, Pa.," dia. 4¾ x h. 10 / **$40** / 7-22 Kinzle.

Ceramics and Glass

478. Stoneware, 19th c. Left to right: jar with lid, blue decoration, base hairline crack, small rim flake, stamped "Belmont Ave. Pottery," dia. 6 x h. 11 / **$65**; jug, blue decoration, minor lip chips, stamped "A.K. Ballard, Burlington, Vt.," h. 14¼ / **$30** / 7-22 Kinzle.

479. Stoneware jar, blue decoration, large chip on rim, 19th c., dia. 10 x 17 / **$60** / 7-22 Kinzle.

480. Stoneware crock, blue decoration, hairline crack, some chips and flaking, stamped "N.A. White & Son, Utica, N.Y.," 19th c., dia. 13¼ x h. 14 / **$60** / 7-22 Kinzle.

481. Stoneware pitchers, 19th c. Left to right: cream glaze, blue decoration and "1894," hairline crack, some rim chips, h. 7½ / **$40**; light brown glaze, blue decoration, some rim chips, h. 7½ / **$50** / 7-22 Kinzle.

482. Stoneware crock, blue decoration, hairline crack, inside rim chips, stamped "New York Stoneware Co.," 19th c., dia. 11½ x h. 11½ / **$65** / 7-22 Kinzle.

483. Stoneware crocks, blue decoration, 19th c. Left to right: cracked, stamped "E.S. Fox, Ahtens [sic]," dated "1838," dia. 8¾ x h. 6½ / **$70**; two hairline cracks, rim chips, stamped "White & Wood, Binghamton, N.Y.," dia. 10¾ x h. 10 / **$60** / 7-22 Kinzle.

484. Stoneware jar, blue decoration and "1860," underrim chip, dia. 9¾ x h. 14 / **$70** / 7-22 Kinzle.

485. Stoneware crock, blue decoration, cracked, stamped "Whites Utica," N.Y., 19th c., dia. 12½ x h. 12½ / **$80** / 7-22 Kinzle.

486. Stoneware churn, blue decoration, cracked down reverse, some hairline cracks, 19th c., dia. 10¾ x h. 21 / **$95** / 7-22 Kinzle.

Ceramics and Glass

487. Stoneware canning jars, 19th c. Left to right: blue decoration, dia. 3½ x h. 8¾ / **$135**; blue decoration and "1871," some rim chips, dia. 3½ x h. 7½ / **$95** / 7-22 Kinzle.

488. Stoneware, blue decoration, 19th c. Left to right: crock, chip on handle, hairline crack at base, stamped "Edwards & Co.," dia. 11½ x h. 11½ / **$100**; jug, rim chip, stamped "Ottoman Bros. & Co., Fort Edward, N.Y.," h. 16 / **$50** / 7-22 Kinzle.

489. Stoneware jugs, 19th c. Left to right: blue decoration, blue stencil "S. Horkheimer & Son. No. 1221 Main Street, Wheeling. W. Va. 3," h. 16 / **$75**; impressed and blue decoration, stamped "John Burger, Rochester," N.Y., h. 14 / **$135** / 7-22 Kinzle.

490. Stoneware jugs, 19th c. Left to right: blue decoration, stamped "West Troy, N.Y., Pottery," h. 14 / **$110**; blue decoration and "1879," stamped "West Troy, N.Y., Pottery," h. 16½ / **$110** / 7-22 Kinzle.

491. Stoneware, blue decoration, 19th c. Left to right: spittoon, underbase chip, dia. 10 x h. 5¼ / **$100**; spouted milk pan, small crack, dia. 12 x h. 4½ / **$75** / 7-22 Kinzle.

492. Stoneware, 19th c. Left to right: jar, blue decoration, several rim chips, dia. 8 x h. 11½ / **$100**; jug, blue decoration, blue stencil "N. Crawley. Market-Square. Wheeling. Va. 3," rim chip, h. 16½ / **$160** / 7-22 Kinzle.

493. Stoneware jar, blue decoration, blue stencil "Hamilton and Jones, Greensboro, Pa. 15," one crack, 19th c., dia. 13 x h. 24 / **$150** / 7-22 Kinzle.

494. Stoneware jugs, 19th c. Left to right: blue decoration, stamped "C. Crolius, Manufacturer, New York," h. 14 / **$150**; blue decoration, stamped "N. Clark & Co., Mount Morris," small surface chip, h. 16 / **$170** / 7-22 Kinzle.

Ceramics and Glass

495. Stoneware, 19th c. Left to right: butter crock with lid, blue decoration, knob and inside rim chipped, dia. 8¼ x h. 4¾ / **$110**; milk crock, blue decoration, dia. 13 x h. 7½/ **$190** / 7-22 Kinzle.

496. Stoneware crocks, 19th c. Left to right: blue decoration and "1874," crack on reverse, dia. 7 x h. 9¼ / **$35**; blue decoration, dia. 12 x h. 14 / **$170** / 7-22 Kinzle.

497. Stoneware, blue decoration, 19th c. Left to right: milk pan, dia. 12¼ x h. 6½ / **$200**; jar, base hairline crack, dia. 6¾ x h. 11½ / **$40** / 7-22 Kinzle.

498. Stoneware, 19th c. Left to right: crock, blue decoration, minor rim flakes, stamped "Wm. E. Werner, West Troy," N.Y., dia. 7½ x h. 11 / **$45**; jug, blue decoration, stamped "Frank B. Norton, Worcester, Mass.," h. 11 / **$175** / 7-22 Kinzle.

499. Stoneware, 19th c. Left to right: jar, blue and stamped decoration, misshapen in kiln, dia. 6 x h. 12½ / **$60**; harvest jug, blue and stamped decoration, h. 11½ / **$220** / 7-22 Kinzle.

500. Stoneware pitchers, 19th c. Left to right: blue decoration, stamped "W.H. Lehew, Strasburg," Va., repaired spout, h. 14 / **$210**; blue decoration, stamped "W.H. Lehew, Strasburg," repaired full-length crack, h. 10½ / **$75** / 7-22 Kinzle.

501. Stoneware pitchers, 19th c. Left to right: raised blued and incised decoration, stamped "S.E.E.," h. 9½ / **$150**; blue decoration, h. 10¼ / **$240** / 7-22 Kinzle.

502. Stoneware crocks, blue decoration, 19th c. / ex-coll. Wiltshire. Left to right: probably N. Y., h. 11 / **$225**/ est. $200-250; stamped "Cowden & Wilcox, Harrisburg, Pa.," h. 11 / **$250** est. $200-300 / 2-1 SPB.

503. Stoneware butter churn, blue decoration, stamped "Higgins & Co., Cleveland, O.," 19th c., dia. 9½ x h. 20 / **$225** / 7-22 Kinzle.

Ceramics and Glass

504. Stoneware, blue decoration, 19th c. Left to right: pitcher, h. 12¾ / **$130**; jar, incised daisy, cracks and chips, stamped "C. Crolius, Manufacturer, Manhattan-Wells, New York," dia. 7½ x h. 11¼ / **$225** / ex-coll. McKearin / 7-22 Kinzle.

505. Stoneware, 19th c. Left to right: cooler, blue decoration, dia. 9¼ x h. 13¼ / **$250**; jug, blue stencil "A. P. Donaghho, Parkersburg, W. Va," strap handle broken off, rim chips h. 14 / **$55** / 7-22 Kinzle.

506. Stoneware cooler, blue decoration and "1863," base dia. 11 x h. 22 / **$260** / 7-22 Kinzle.

507. Stoneware molasses barrel or cooler, blue decoration, 19th c., base dia. 10 x h. 22 / **$270** / 7-22 Kinzle.

508. Stoneware crocks, 19th c. Left to right: blue stencil spread eagle with banner "Eagle Pottery," dia. 9¼ x h. 10½ / **$260**; tan glaze, blue stencil stars, some cracks, dia. 6¾ x h. 9½ / **$35** / 7-22 Kinzle.

509. Stoneware pitcher, blue decoration, hairline crack, North Carolina, 19th c., h. 10½ / **$250** / est. $200-250 / ex-coll. Wiltshire / 2-1 SPB.

510. Stoneware cooler jug, blue decoration, stamped "S. Hart, Fulton" and "H.A. Griffin, Oswego Center, N.Y.," 19th c., h. 15 / **$290** / 7-22 Kinzle.

511. Stoneware jugs, blue decoration, 19th c. Left to right: h. 14 / **$85**; h. 15 / **$260** / 7-22 Kinzle.

512. Stoneware crock, blue decoration, small rim chip, 19th c., dia. 10½ x h. 10¼/ **$300** / 7-22 Kinzle.

513. Stoneware jar, blue decoration, two incised hearts with "C.S." enclosed, incised "F.S." beneath each heart, one crack, some rim chips, wire applied around collar, 19th c., dia. 12 x h. 17¾/ **$300** / 7-22 Kinzle.

514. Stoneware pitchers, 19th c. Left to right: light brown glaze, blue decoration, h. 10¼ / **$240**; blue decoration, h. 10¼ / **$300** / 7-22 Kinzle.

Ceramics and Glass

515. Stoneware pitchers, 19th c. Left to right: blue decoration, blue stencil "Williams & Reppert, Greensboro, Pa.," h. 11½ / **$320**; blue decoration, h. 9 / **$325** / 7-22 Kinzle.

516. Stoneware crock, blue decoration, one lug handle missing, several cracks, stamped "Harrington & Burger, Rochester," N.Y., 19th c., dia. 12½ x h. 14¾ / **$330** / 7-22 Kinzle.

517. Stoneware, 19th c. Left to right: pitcher, blue decoration, cracked, h. 7 / **$95**; inkwell, blue decoration, repaired edge chip, stamped "A.F. Miller, Gallatin," dia. 5¾ x h. 2 / **$380**; mug, blue bands, h. 5 / **$25** / 7-22 Kinzle.

518. Stoneware pitchers, 19th c. Left to right: tan glaze, blue decoration, h. 10¼ / **$130**; blue decoration, multiple impressed rings, stamped "N. Cooper & Power, Maysville, Ky," rim and lip chips, h. 11 / **$350** / 7-22 Kinzle.

519. Stoneware double cooler with lid, blue decoration, pewter spigot, 19th c., dia. 11 x h. 21½ / **$370** / 7-22 Kinzle.

520. Stoneware crock, blue decoration, stamped "Whites Utica," N.Y., 19th c., dia. 11 x h. 13/ **$300** / 7-22 Kinzle.

521. Stoneware crock, blue decoration, stamped under handle "Solomon Bell, Strasburg, Virginia," 19th c., h. 15¼ / **$375** / est. $300-400 / museum / ex-coll. Wiltshire / 2-1 SPB.

522. Stoneware jug, incised blue decoration, probably Ulbridge, N.J., 19th c., h. 17¼ / **$425** / est. $400-600 / 11-18 SPB.

523. Stoneware jugs and crocks, blue decoration, 19th c. Left to right: stamped "W. Roberts, Binghamton, N.Y.," h. 16½ / **$475** / est. $500-700 / dealer; h. 13½ / **$300** / est. $300-400; stamped "Hartum, Ottoman & Co., Fort Edward, N.Y.," chips on neck, h. 16 / **$250** / est. $300-400; stamped "C.P. Rotier, Grocer, Rondout, N.Y.," h. 11½ / **$350** / est. $300-400 / 2-1 SPB.

Ceramics and Glass

524. Stoneware inkwell, cream glaze, stamped "Ithemar Conkey. Amherst. Mass. 1835," probably a presentation piece, dia. 6½ x h. 1½, / **$475** / est. $350-400 / illus. in William E.Covill, *Ink Bottles and Inkwells*, no. 1192; ex-coll. Covill / 6-24 Skinner.

525. Stoneware inkwell, blue decoration, some chips, stamped "N. Clark, Jr., Athens, N.Y., Globe Works," 19th c., dia. 7 / **$200** / est. $200-250 / 9-22 Skinner.

526. Stoneware flask, stamped "C. Crolius Manufacturer New York," 1794-1814 rim chip, gray, no decoration / **$250** / dealer / 1-14 Skinner.

527. Stoneware inkwell, rim chip, stamped "C. Boynton & Co. Troy," N.Y. 1826-29, dia. 3¾ x h. 1½, / **$950** / est. $500-600 / provenance: Kindler Collection / 6-24 Skinner.

528. Stoneware inkwell, gray with blue glaze, minor base chip, stamped "C. Crolius Manufacturers, Manhattan-Wells, New York," 1794-1814 / **$1,600** / est. $700-800 / provenance: Kindler Collection / 6-24 Skinner.

529. Stoneware churn, blue decoration, brown glazed lid, rim chip, wooden stomper, stamped "Whites Utica, N.Y.," 19th c., dia. 9 x h. 18½ / **$500** / 7-22 Kinzle.

530. Stoneware inkwell, gray and blue glaze, age crack, stamped "M. Tyler & Co. Albany," N.Y., 1820-40, dia. 4 x h. 1⅞ / **$525** / est. $350-400 / provenance: Kindler Collection / 6-24 Skinner.

531. Stoneware jug, blue decoration, stamped "Boston," probably Jonathan Fenton's Boston Pottery, 1794-97, h. 11¾ / **$550** / est. $1,000-1,500 / 2-1 SPB.

532. Stoneware jug, incised and blue decoration, stamped "Commeraws Stoneware," N.Y. early 19th c., h. 17 / **$700** / ex-coll. McKearin / 7-22 Kinzle.

533. Stoneware cooler, incised blue decoration of tobacco leaves (shown) and flowering branch, 19th c., h. 25½ / **$700** / 1-6 Garth's.

Ceramics and Glass

534. Stoneware coffee pot, completely blued spout and handle, spout and rim chipped, one crack, lid missing, 19th c., h. 8¼ / **$750** / 7-22 Kinzle.

535. Stoneware crock, blue decoration, two rim chips, 19th c., dia. 11½ x h. 12¾ / **$900** / 7-22 Kinzle.

536. Stoneware cooler urn, blue decoration, incised birds, attached pedestal and saucer, stamped "Somerset Potters Works," 19th c., dia 10¾ x h. 19¼ / **$925** / sold 5-77 Garth's for $1,700 / 7-22 Kinzle.

537-538. Pair of stoneware gate posts, blue decoration, stamped "R.T. Williams, No 119.," one post has crack, 19th c., h. 22½ / **$950** / 7-22 Kinzle.

539. Stoneware water pump, blue decoration, 19th c., base dia. 7 x h. 20 / **$1,200** / 7-22 Kinzle.

540. Stoneware bowl, blue decoration, incised outside and inside (inside has fish), inscribed "Eliz Crane, May 22, 1811, C Crane," N.J., 19th c., dia. 15½ x h. 7¾ / **$12,500** (record for a piece of American stoneware) / est. $1,500-2,500 / dealer as agent for private collector / 4-1 SPB.

541. Stoneware grotesque jar, brown glaze, probably northern Ohio, 19th c., h. 12 / **$2,600** / 7-22 Kinzle.

542. Stoneware jug, incised blue decoration, stamped "N. Clark, Jr., Athens, N.Y.," 1843-92, h. 14 / **$1,300** / est. $2,000-3,000 / illus. in Webster, *Decorated Stoneware Pottery of North America*, no. 155 / 11-18 SPB.

543. Stoneware jug, blue and incised decoration stamped "Liberty For. ev." and "Warne & Letts 1807," South Amboy, N.J., h. 11½ / **$2,500** / est. $1,000-1,500 / exhibited at Williamsburg, 1975 / 2-1 SPB.

544. Stoneware bird house with old wooden gate narrowing the entrance hole and original bird's nest, incised blue decoration, several hairline cracks, inscribed "M & T Miller, New Port, Perry Co., Penn.," 19th c., h. 9 / **$2,350** / 7-28 Garth's.

Ceramics and Glass

545. Chalkware fireman, probably Penn., 19th c. / **$1,250** / 4-4 Pennypacker.

546. Chalkware, probably Penn., 19th c. Left to right, top to bottom: madonna and child, h. 12 / **$80** ($88) / est. $200-300; watch stand, h. 12 / **$260** ($286) / est. $700-900; whippet, l. 10½ / **$220** ($242) / est. $350-400 / 3-10 Christie's.

547. Chalkware, probably Penn., 19th c. Left to right, top to bottom: dog holding bucket, h. 6 / **$220** ($242) / est. $300-400 / dealer; plaque of Andrew Jackson, 4¾ x 5¾ / **$260** ($286) / est. $300-400 / dealer; plaque of cherub on dolphin, 6¼ x 6¾ / **$150** ($165) / est. $250-350; plaque of mother and child, 4¾ x 5¾ / **$220** ($242) / est. $250-350; cat, h. 5½ / **$200** ($220) / est. $250-350; plaque of bird, 5½ x 7 / **$180** ($198) / est. $250-350 / 3-10 Christie's.

548. Chalkware, probably Penn. 19th c. Left to right, top to bottom: rooster, h. 7¼ / **$200** ($220) / est. $300-500 / dealer; dove, h. 11 / **$300** ($330) / est. $400-500; ram, 4 x 4 / **$170** ($187) / est. $250-350 / dealer; spaniel, h. 6 / **$150** ($165) / est. $250-350; cat, articulated head, l. 6 / **$320** ($352) / est. $400-500 / dealer; rabbit, h. 5 / **$160** ($176) / est. $250-350; two-part leaf mold (plus three continental figures, not shown), dia. 3½ / **$100** ($110) / est. $200-250; lamb and ewe, some breaks, l. 9¼ / **$180** ($198) / est. $250-350; cat, h. 6¼ / **$160** ($176) / est. $250-300 / 3-10 Christie's.

Ceramics and Glass

549. Chalkware, probably Penn., 19th c. Left to right, top to bottom: girl, unpainted, restored, h. 10 / **$130** ($143) / est. $300-400 / dealer; shepherd, h. 12 / **$190** ($209) / est. $300-400; boy and dog, h. 10½ / **$150** ($165) / est. $300-500; cat, h. 7½ / **$200** ($220) / est. $300-500; man, h. 8½ / **$220** ($242) / est. $350-450 / dealer; man and woman, h. 8¼ / **$200** ($220) / est. $300-400; cat, h. 7½ / **$320** ($352) / est. $300-350; woman, h. 8 / **$140** ($154) / est. $200-250; girl and lamb, h. 5¼ / **$180** ($198) / est. $250-350; horse and rider, h. 6¾ / **$320** ($352) / est. $350-450 / dealer / 3-10 Christie's.

550. Chalkware, probably Penn., 19th c. Left to right, top to bottom: dog, 4¼ x 3 / **$60**; roosters, 8¼ x 6¼ / **$495**; lamb, 5 x 3½ / **$75**; doves, h. 5 / **$285**; ram, 5 x 3¾ / **$95**; peach bank, h. 2¾ / **$35**; deer, h. 5½ / **$225** / 5-5 Garth's.

Ceramics and Glass

551. Chalkware, probably Penn., 19th c. Left to right: cooing doves / **$190**; poodle with basket / **$125**; cardinal / **$160** / 4-4 Pennypacker.

552. Rockingham cake stand with pinwheel and hex cutout center, possibly Penn., early 19th c. / **$1,250** / 4-4 Pennypacker.

553. Pair of Bennington "cottage-type" vases, one has rim repair, 1850-58, h. 7½ / **$450** / est. $200-400 / 11-16 SPB.

554. Pair of whale-oil lamps, vaseline glass, minor chips, probably Boston and Sandwich Glass Co., circa 1840, h. 9 / **$500** / est. $250-350 / 9-30 SPB.

555. American porcelain. Left and right: pair of white tea cups and saucers, excellent condition, marked with printed "U.P.W." (Union Porcelain Works, Greenpoint, N.Y.), eagle's head, and "S" in green, 1877-87 / **$425** / est. $200-300. Center: painted Tucker pitcher, excellent condition, Philadelphia, 1825-38, h. 9¼ / **$550** / est. $300-500 / 11-16 SPB.

556. Pair of candlesticks, vaseline glass, minor chips, probably Boston and Sandwich Glass Co., circa 1840, h. 10¾ / **$550** / est. $300-400 / 9-30 SPB.

557. Flint crystal goblet (the "Decatur" goblet), probably Kensington, Philadelphia, circa 1820, h. 6⅜ / **$2,100** / est. $1,750-2,500 / private / 2-18 Sloan.

558. Tucker "Walker shape" pitcher, gilt decoration, small chips and glaze cracks, Philadelphia, 1825-38, h. 5⅞ / **$550** / est. $500-700 / 4-27 SPB.

559. Historical flask (McKearin GII-12), "W.C." Eagle-Cornucopia, olive-yellow, Pittsburgh District, 1810-30, half-pint / **$6,900** / est. $2,500-3,500 / provenance: Lefevre Collection / 6-24 Skinner.

Ceramics and Glass

560. Glass inkwell, blown three-mold, probably Boston and Sandwich Glass Co., circa 1840, dia. 2 x h. 1⅝, / **$625** / estimate $500-600 / provenance: Lefevre Collection / 6-24 Skinner.

561. American eagle flasks, 19th c. Left to right: (McKearin GII-19) eagle in flight perched on two draped flags (shown), reverse has spray of morning glories, aquamarine, excellent condition, Mid-Western, pint / **$1,100** / est. $600-800; (McKearin GII-45) eagle perched on oval frame (shown), reverse has cornucopia, aquamarine, excellent condition, probably Kensington Philadelphia Glass Works, half-pint-11 / **$150** / est. $200-250; (McKearin GII-9) eagle and shield above small oval frame (shown), reverse has eagle in flight grasping serpent in its beak, deep aquamarine, excellent condition, Monongahela-early Pittsburgh district, pint-17 / **$6,750** / est. $3,000-5,000 / 2-4 SPB.

562. Scroll flasks, 19th c. Left to right, top to bottom: sapphire blue, small chip on lip, pint-36 / **$900** / est. $1,000-1,500; emerald green, excellent condition, probably Pittsburgh, pint-35 / **$2,300** / est. $1,200-1,500; sapphire blue, small chip on lip, possibly Lancaster, N.Y., Glass Works, pint-36 / **$2,000** / est. $1,200-1,500; aquamarine, chip on lip, quart-36 / **$80** / est. $150-200; aquamarine, excellent condition, quart-35 / **$1,100** / est. $200-300 / 2-4 SPB.

563. Historical flask (McKearin GVI-3), Baltimore Monument-Liberty Union, brilliant yellow-olive, some inside base stains and exterior scratches, Baltimore Glass Works, 1820-52, pint / **$3,600** / est. $2,500-3,500 / provenance: Lefevre Collection / 6-24 Skinner.

564. Glass inkwell (McKearin GII-15), blown three-mold, brilliant sapphire blue, Mount Vernon Glass Works, N.Y. circa 1820-40, dia. 2¼ x h. 1¾ / **$2,650** / est. $2,000-2,500 / provenance: Lefevre Collection / 6-24 Skinner.

565. Chinese export tea bowl and saucer, blue and gold decoration with the arms of the State of New York, circa 1800 / **$500** / est $400-600 / provenance: Sarah Potter Conover, N.Y. / 9-9 SPB.

566. Chinese export plate from George Washington's Society of Cincinnati service (design depicts Fame trumpeting and bearing the emblem of the society), 1784-95, dia. 9¾ / **$8,000** / est. $12,000-18,000 / 11-16 SPB.

567. Historical flask (McKearin GII-60), eagle-oak tree, yellow-green, circa 1820-50, half-pint / **$1,900** / est. $1,500-2,000 / provenance: Lefevre Collection / 6-24 Skinner.

568. Set of Chinese export porcelain, 1796-1810, sold as three lots. Left and right: pair of tea bowls and saucers, hairline crack in one bowl / **$375** / est. $300-500. Center, left to right: pitcher, h. 5⅜ / **$600** / est. $300-500; bowl, dia. 5½ / **$500** / est. $250-450 / 2-2 SPB.

Ceramics and Glass

569. Gaudy Dutch "Butterfly" pattern (minor variations), all proof condition, Staffordshire, England, late 18th-early 19th c. Left to right: cup and saucer / **$475**; cup and saucer / **$450**; plate, 7¼ / **$375**; cup and saucer / **$400**; cup and saucer / **$450** / 4-4 Pennypacker.

570. Transfer-printed plates with portraits of Lafayette, circa 1825. Left to right: blue border, Clews, Staffordshire, dia. 8¾ / **$400** / est. $250-350; floral border, Prattware, dia. 7 / **$475** / est. $400-500; blue border, Clews, Staffordshire, dia. 7⅝ / **$400** / est. $200-250 / ex-coll. Arthur J. Sussel, Philadelphia / 2-18 Sloan.

571. Staffordshire historical blue plates. Left to right: pair of "Harvard College" (one shown), deep blue, printed mark "Ralph Stevenson and Williams," circa 1820, dia. 10 / **$500** / est. $200-300; "Fair Mount Near Philadelphia," medium blue, printed mark "Joseph Stubbs," circa 1820, dia. 10¼ / **$225** / est. $100-150 / 9-30 SPB.

572. Liverpool transfer-printed creamware jugs, circa 1800. Left to right: printed in black, one side (shown) with scenes of tree-felling, ship-building, and central poem, other side with eagle perched on cannon above inscription "Peace, Plenty and Independence" flanked by two female figures, spout restored, h. 7⅞ / **$450** / est. $400-600; printed in black, one side (shown) with two ships engaged in battle above inscription "The Macedonian & the United States," other side as lefthand piece, eagle beneath spout (small restoration) over inscription "E Pluribus Unum," h. 9 / **$650** / est. $500-750 / private / 2-2 SPB.

573. Liverpool transfer-printed creamware jugs, circa 1800. Left to right: printed in black, one side (shown) with eagle bordered by circlets inscribed with names of sixteen states, other side with American ship, eagle beneath spout (chipped), h. 8⅛ / **$450** / est. $250-450; printed in black, one side (shown) with two ships enameled in red, blue, yellow and green, other side as lefthand piece, wreath inscription beneath spout (repaired) reads "Success to America," traces of black and gold cold decoration, h. 9⅛ / **$425** / est. $400-600 / 2-2 SPB.

574-575. Liverpool transfer-printed creamware jug, printed in black and sepia including signature "F. Morris," enameled in red, blue, green, and yellow, traces of gilt decoration, rim and spout repairs, circa 1805, h. 10¾ / **$800** / est. $600-900 / 2-2 SPB.

576-577. Liverpool transfer-printed creamware jug, printed in black including signature "F. Morris, Shelton," some imperfections, circa 1800, h. 13⅛ / **$900** / est. $600-900 / 2-2 SPB.

Ceramics and Glass

578. Staffordshire transfer printed jugs, circa 1815. Left to right: portrait of Lawrence (shown), other side portrait of Capt. Bainbridge, mottled purple luster collar and base, h. 4¾ / **$600** / est. $500-600; Maj. Genl. Brown (shown), other side Decatur, purple luster base, shoulder, neck, and handle, centered purple floral spray, h. 4¾ / **$700** / est. $600-800; Decatur, other side Lawrence, purple luster shoulder, neck, and handle, excellent condition, h. 4½ / **$900** / est. $600-800 / ex-coll. Arthur J. Sussel, Philadelphia / 2-18 Sloan.

579. Transfer-printed jugs, early 19th c. Left to right: the *Constitution* in close action with the *Guerriere*, 1815 (shown), other side Capt. MacDonough's victory at Lake Champlain, purple luster banded base, shoulder, neck, and handle, very good condition, Bentley, Wear, and Bourne, engravers and printers, Shelton, Staffordshire, h. 7½ / **$1,100** / est. $800-1,200; naval engagement of *L'Insurgent* and the *Constellation*, 1799 (shown), other side a farm scene, Liverpool, h. 7⅝ / **$600** / est. $600-800; the *Constitution* in close action with the *Guerriere* (shown), other side Capt. MacDonough's victory, under spout a spread eagle, shield, and E Pluribus Unum banner beneath sixteen stars, purple luster banded base, shoulder, neck and handle, Bentley, Wear, and Bourne, engravers and printers, Staffordshire, h. 7½ / **$1,500** / est. $800-1,200 / ex-coll. Arthur J. Sussel, Philadelphia / 2-18 Sloan.

580. Transfer printed jugs, early 19th c. Left to right: Com. MacDonough's Victory on Lake Champlain Sept. 11, 1814 (shown), other side First View of Com. Perry's Victory, under spout a transfer print from the frontispiece for the book *The Naval Monument* (Boston, 1816), molded shell spout, purple luster banded base, shoulder, neck and handle, very good condition, Bentley, Wear and Bourne, engravers and printers, Shelton, Staffordshire, h. 9⅛ / **$4,500** (record for a Staffordshire jug) / est. $800-1,200 / private; Second View of Com. Perry's Victory (shown), other side Com. MacDonough's Victory, molded shell hand grip under spout, purple luster banded base shoulder, neck, and handle enriched with stylized purple resist luster leafage, Bentley, Wear and Bourne, engravers and printers, Shelton, Staffordshire, h. 9½ / **$4,500** (jugs sold consecutively, ties record) / est. $1,500-2,000 / private / ex-coll. Arthur J. Sussel, Philadelphia / 2-18 Sloan.

Textiles

581. Jacquard woven coverlet, red, white and blue, signed "Made by Thomas Marsteller. Lo. Saucon Penn. 1840," / **$200** / est. $200-300 / 4-29 SPB.

582. Jacquard woven coverlet, blue and white, single woven, mid-19th c. / **$300** / est. $400-500 / 11-18 SPB.

583. Jacquard woven coverlet (detail), red, green and blue wool on buff ground, signed "Made by Daniel Goodman, Nescopeck, Luzerne Co, for Mary Jenkins, Penn. 1842," 76 x 96 / **$450** / private / 4-8 Theriault.

584. Jacquard woven coverlet (detail), red, green and blue wool on buff ground, signed on border "Made by Wm. Ney, Meyerstown, Lebanon Co., Pa.," 80 x 86 / **$700** / private / 4-8 Theriault.

Textiles

585-586. Jacquard woven coverlet, red, green, and rust wool on buff cotton ground, very good condition, signed "Made by J. Lutz, E Hempfield Township, for Atty Martin, 1848," Penn. / **$5,500** (record) / private / 4-8 Theriault.

587. Jacquard woven coverlet, blue and white, signed "DDH [David Haring]," inscribed "Hannah Van Houten Dec. 18. 1834," N.Y. or N.J. / **$1,500** / est. $800-1,200 / 2-1 SPB.

588. Coverlet, chintz applique on linen, American, late 18th c. / **$1,300** / est. $1,000-2,000 / 9-30 SPB.

589. Coverlet, crewelwork on linen, New England, 18th c. / **$2,000** / est. $2,500-3,500 / 9-30 SPB.

590. Coverlet, stenciled and quilted cotton, minor stains, one small patch, probably Mass., circa 1840 / **$2,200** / est. $1,500-2,000 / dealer / 9-30 SPB.

591. Coverlet, stenciled in green, brown, blue and pink on white cotton, minor staining, signed "Sarah Mooers," probably New England, circa 1820 / **$2,200** / no catalog estimate / dealer / 11-18 SPB.

Textiles

592. Appliqued quilt, cotton, green, red, and orange on white ground, elaborate quilting / **$225** / est. $300-500 / 2-1 SPB.

593. Appliqued quilt, red, green, and yellow cotton on white cotton / **$350** / est. $300-400 / 11-18 SPB.

594. Pieced and appliqued quilt, red, yellow, green, and blue cotton on white cotton / **$700** / est. $300-500 / 11-18 SPB.

595. Pieced and appliqued quilt, red, green, yellow and blue calico patches and chintz appliques, each square signed by stitcher, probably Lexington, Va., 1845-50 / **$1,000** / est. $700-900 / 11-18 SPB.

596. Pieced quilt, calico and chintz in brown, tan, gray, green, maroon, pink, and yellow / **$1,000** / est. $800-1,200 / 4-29 SPB.

597. Trapunto quilt, elaborate stitching, 19th c. / **$1,200** / est. $1,200-1,500 / 2-1 SPB.

598. Pieced quilt, red, yellow, green, and blue calico, Cornelia Ann Schenck, Long Island, 1851 (sold together with a sunburst doll's quilt, not shown) / **$2,400** / est. $2,000-3,000 / provenance: descended in the family of the maker to present owner / 11-18 SPB.

599. Appliqued quilt, calico and chintz, most squares signed or initialed by stitcher, central square signed "Eliza Jane Crolius Potter, NY 1849" / **$1,300** / est. $1,500-2,500 / 4-29 SPB.

Textiles

600. Pieced quilt made from remnants of painted silk dresses belonging to Martha Washington and given to her dressmaker as mementoes, flaking and fabric loss in painted areas, pieced in mid-19th c. / **$2,500** / est. $4,000-6,000 / provenance: the Mann-Denlar-Reynolds families; exhibited at The Chicago Historical Society, 3-51 / 11-17 SPB.

601. Pair of crewel-embroidered bed hanging panels (one shown), wool on linen, numerous repairs, fraying and some stains, probably Boston, 1740-60, 39 x 93½ / **$1,200** / est. $3,000-5,000 / 11-18 SPB.

602. Sampler, blue, red, green and yellow thread, signed "Jane Pullyn," probably Penn., dated "1742," 10¾ x 15¾ / **$1,200** / est. $800-1,000 / ex-coll. Arthur J. Sussel, Philadelphia / 11-18 SPB.

603. Sampler, brown, green, pink, red, white and blue on linen ground, some wear spots, signed "Margarat Mure Aged Nine," circa 1815, 13¾ x 11¾ / **$1,200** / est. $1,000-1,500 / private / provenance: Ginsburg and Levy, Inc., N.Y. / 2-1 SPB.

604. Needlework picture, tent-stitched wool, silk, and metallic yarns on linen, original frame and old glass, Boston, 18th c., 26 x 22 / **$18,500** (record) / est. $2,500-3,500 / dealer / provenance: Samuel Morse family, Medford, Mass. / 9-22 Skinner.

605. Hooked rug, Frost pattern, 19th or 20th c. / $350 / 9-14 Julia.

Textiles 213

606. Hooked rug, blue, gray, and brown fabric, circa 1920, 46 x 32¾ / **$500** / est. $400-500 / 2-1 SPB.

607. Hooked rug, green, beige, pink, blue, and yellow fabric, circa 1920, 45 x 33 / **$750** / est. $400-600 / 2-1 SPB.

608. Hooked rug, probably Penn., 20th c., 38 x 93 / **$1,500** / est. $1,000-1,500 / 11-18 SPB.

609. "Penwiper" rug, wool with felt applique and embroidery, Maine, 19th century / **$1,350** / dealer / 6-23 Morrill.

Textiles

610. Hooked rug, tan, green, orange, red, white, and brown wool, 59-30½ / **$950** / est. $1,200-1,500 / 2-1 SPB.

611. Coffin shawl, red, white, blue, and gold knitted wool, circa 1865 / **$1,700** / est. $1,000-1,500 / said to have been used to drape Lincoln's coffin as he lay in state / 2-4 SPB.

612. Thirteen-star American flag, bunting, small holes, faint stains, 35½ x 24½ / **$1,700** / est. $1,500-2,000 / 2-3 SPB.

613. Thirteen-star American flag, bunting, several holes, some fraying, 35½ x 22 / **$1,000** / est. $500-700 / 11-18 SPB.

Metals

614. Water pitcher, silver, marked on the base "I.[John] W. Forbes," New York, circa 1825, 27 ozs. 10 dwts., h. 11¾ / **$525** / est. $500-600 / 11-17 SPB.

615. Water pitcher, silver, John Kitts, Louisville, circa 1840, 21 ozs., h. 11½ / **$750** / est. $600-650 / 11-17 SPB.

616. Creamer, silver, marked on the base three times "DD" (Daniel Dupuy), Philadelphia, circa 1760, 3 ozs. 5 dwts., h. 4¼ / **$1,100** / est. $600-800 / 11-17 SPB.

617. Porringer, silver, handle marked "[Benjamin] Burt," Boston, circa 1770, 9 ozs. 15 dwts., l. 8¼ / **$1,000** / est. $1,200-1,500 / 2-2 SPB.

618. Porringer, silver, Saunders Pitman, Providence, R.I., 18th c., 4½ ozs., dia. 4½ / **$550** / est. $500-700 / 9-22 Skinner.

619. Porringer, silver, handle marked "Samuel Burt," Boston, circa 1750, 7 ozs. 10 dwts., dia. at lip 5¼ / **$1,000** / est. $1,500-2,000 / 11-17 SPB.

Metals

620. Cake basket, silver, Hyde & Goodrich, New Orleans, circa 1840, 25 ozs., l. 13 / **$1,000** / est. $600–800 / 11-17 SPB.

621. Cake basket, Baldwin Gardiner, New York, circa 1825, 45 ozs. 10 dwts., l. 15¾ / **$1,500** / est. $900–1,100 / 11-17 SPB.

622. Caster, silver, finial missing, marked below crown "AT" (Andrew Tyler), Boston, circa 1720, 5 ozs. 5 dwts., h. 5⅝ / **$1,400** / est. $1,500–2,000 / 11-17 SPB.

623. Silver, marked twice on each base "JR" (Joseph Richardson, Jr.), Philadelphia, circa 1800. Left to right: sugar vase, 13 ozs. 5 dwts., h. 8½ / **$1,200** / est. $1,200–1,500; teapot, 19 ozs. 15 dwts. gross, h. 6¾ / **$1,600** / est. $1,200–1,500 / 11-17 SPB.

624. Sugar bowl, silver, marked on the base three times "I.L." (John Leacock?), probably Philadelphia, circa 1775, 15 ozs., h. 7¼ / **$2,300** / est. $1,000-1,200 / 2-2 SPB.

625. Water pitcher, silver, Fletcher & Gardiner, Philadelphia, circa 1820, 42 ozs. 15 dwts., h. 12 / **$1,600** / est. $800-1,000 / 11-17 SPB.

626. Tankard, silver, spout a later addition, marked near handle below lip "NM" (Nathaniel Morse), Boston, circa 1725, 24 ozs., h. 6¾ / **$1,400** / est. $2,000-2,500 / 11-17 SPB.

627. Mug, silver, Jacob Hurd, Boston, circa 1750, 12 ozs. 5 dwts., h. 5⅛ / **$2,300** / est. $1,800-2,400 / 2-2 SPB.

628. Tankard, silver, handle initialed "C. & H.B.L. to J.R.I. & M.W." (Charles and Harriet Lowell to James Russell and Maria White Lowell), Benjamin Burt, Boston, circa 1780, 22 ozs., h. 7¾ / **$2,000** / est. $2,500-3,500 / 2-2 SPB.

629. Coffee pot, silver, marked twice on the base, James Musgrave, Philadelphia, circa 1795, 38 ozs. gross, h. 14¾ / **$1,600** / est. $2,750-3,000 / 11-17 SPB.

Metals

630. Caudle cup, silver, John Hutton, New York, circa 1720, dia. 4¾ x h. 1¾ / **$5,500** / est. $4,000-6,000 / dealer / 2-19 Sloan.

631. Cruet frame, silver, fitted with seven cut-glass bottles probably contemporaneous with frame, Harvey Lewis, Philadelphia, circa 1815, frame 43 ozs., dia. 9¼ / **$4,750** / est. $800-1,200 / private / 11-17 SPB.

632. Sauce boat, silver, marked on the base "[Daniel] Henchman," Boston, circa 1755, 11 ozs. 5 dwts., l. 7½ / **$2,600** / est. $2,000-3,000 / 11-17 SPB.

634. Coffee pot, silver, wooden handle, Daniel Henchman, Boston, circa 1760, 33 ozs. 10 dwts. gross, h. 11½ / **$6,000** / est. $6,000-8,000 / 11-17 SPB.

633. Bowl, silver, marked on the base "IH" (John Hastier), New York, circa 1730, 20 ozs. 5 dwts., dia. 8 / **$13,500** / est. $7,000-10,000 / private / 11-17 SPB.

635. Tea pot, silver, wooden handle, base engraved "E*L" (Elizabeth Loutit, b. 1732), engraved crest a later addition, marked on body at lip near handle "P.VD" (Peter Van Dyck), New York, 1720-40, 22 ozs. gross, h. 7½ / **$47,000** (record for a piece of American silver) / est. $14,000-18,000 / dealer / exhibited at the Museum of the City of New York, 1949-77 / 2-2 SPB.

636. Caster, silver, marked "IC" (John Coney), Boston, circa 1700, about 2 ozs., h. 3¼ / **$5,250** / est. $2,000-2,500 / 10-30 Freeman.

637. Tankard, silver, marked three times next to handle near rim "PS" (Philip Syng), Philadelphia, circa 1770, 33 ozs. 10 dwts., h. 7½ / **$13,500** / est. $10,000-15,000 / exhibited at Pennsylvania Museum of Fine Arts, 1926-65, and Diplomatic Reception Rooms, Department of State, 1970-77 / 2-2 SPB.

638. Three-piece tea service, silver, Samuel Kirk, Baltimore, 1824, 50 ozs. gross / **$1,600** / est. $800-900 / 11-17 SPB.

Metals

639. Three-piece tea service, silver, William G. Forbes, New York, circa 1810, 38 ozs. 15 dwts. gross, teapot h. 8 / **$2,400** / est. $1,500-2,000 / 11-17 SPB.

640. Five-piece tea service (including sugar tongs, not shown), silver, all pieces marked "J. & I. Cox," New York, circa 1840 / **$2,100** / est. $2,500-3,000 / 9-22 Skinner.

641. Charger, pewter, Samuel Hamlin, Hartford, Conn., late 18th c. / **$650** / est. $500-700 / 9-22 Skinner.

642. Pewter, Frederick Bassett, New York, circa 1780. Left to right: plate, marked on the reverse, dia. 8½ / **$475** / est. $400-600; mug, marked on the interior, some repairs, h. 4¾ / **$2,400** / est. $2,000-2,500 / 9-9 SPB.

643. Flagon, pewter, marked indistinctly on the interior, attributed to Thomas D. Boardman, Conn., early 19th c., h. 11⅜ / **$1,100** / est. $1,200-1,500 / 11-18 SPB.

644. Coffee pot, pewter, fair condition with repaired breaks and some pitting, marked "S.S. Hersey," Belfast, Maine, 1840-60 / **$860** / dealer / 8-10 F.O. Bailey.

Metals

645. Coffee pots, pewter. Left to right: marked, Rufus Dunham, Westbrook, Maine (1837-61), h. 10¼ / **$800** / est. $300-500; marked, Roswell Gleason, Dorchester, Mass. (1822-71), h. 10½ / **$950** / est. $300-500 / 11-24 Bourne.

646. Tankard, pewter, marked on interior, Henry Will, New York and Albany, 1761-93, h. 7 / **$8,250** (record for a piece of American pewter) / est. $2,000-3,000 / 4-27 SPB.

647. Set of six cups, pewter, each marked on the interior "O[liver] Trask," Beverly, Mass., circa 1835, h. 5¼ / **$3,750** / est. $2,000-2,500 / 11-18 SPB.

648. Porringer, pewter, New England, circa 1800, l. 6¼ / **$275** / est. $150-250 / 9-30 SPB.

649. Mug, pewter, once silvered, small repair on base, mark of Gershom Jones, Providence, R.I. circa 1800 / **$2,300** / dealer / 1-14 Skinner.

650. Lighting devices, 18th-19th c. Left to right: chandelier / **$375**; lantern / **$250**; double adjustable candle stand / **$625**; candle stand / **$375**; adjustable Betty lamp / **$375** / 7-7 Withington.

651. Lighting devices, 18th-19th c. Left to right: lantern / **$140**; hanging candle holder / **$390**; hanging double-candle holder / **$700**; trammel with pan / **$200**; chandelier / **$450**; "sticking tommy" / **$60** / 7-7 Withington.

Metals

652. Double-candle stand, tinned sheet-iron, New England, 18th c., h. 32½ / **$950** / est. $300-350 / 4-27 SPB.

653. Chandelier, tin, New England, late 18th-early 19th c., dia. 27 x h. 28 / **$1,600** / est. $800-1,200 / dealer / 9-30 SPB.

654. Pair of sconces, tin, possibly 18th c. / **$650** / 4-21 Skinner.

655. Pair of double sconces, tin, some dents, early 19th c. / **$325** / 4-21 Skinner.

656. Pair of mirrored sconces, tin, probably New England, late 18th-early 19th c. / **$1,650** / 4-21 Skinner.

657. Adjustable hinged-arm candle stand, wrought-iron and brass, possibly new England, 18th c., h. 48¼ / **$1,700** / est. $800-1,200 / dealer / 9-30 SPB.

658. Pair of chandeliers (one shown), wrought iron, tin, and wood, original red and green paint, some parts missing, Mass., 18th c., h. 27 / **$10,000** / est. $2,000-3,000 / dealer / provenance: the Putnam family, Rutland, Mass.; used in Masonic Hall in Rutland / 9-22 Skinner.

659. Assembled pairs of sconces, tin, 19th c. Left to right: **$190**; **$175** / 4-21 Skinner.

Metals

660. Pair of mirrored sconces, tin, probably New England, late 18th-early 19th c. / **$1,100** / dealer / 7-25 Withington.

661. Assembled pair of mirrored sconces, tin, probably New England, late 18th-early 19th c., h. 11 / **$950** / est. $500-700 / 9-30 SPB.

662-663. Pair of andirons, brass, stamped "N. Johnson, Founder, Boston," circa 1800, h. 19¾ / **$1,600** / est. $600-900 / 11-24 Bourne.

664-665. Pair of andirons, brass, stamped "R.[ichard] Wittingham. N. York," circa 1800, h. 17¾ / **$1,500** / est. $1,500-2,000 / 11-18 SPB.

666. Six hogscraper candle sticks, 18th-19th c. / **$200** / 4-21 Skinner.

668. Set of fireplace accessories, bell metal, Boston or New York, circa 1800, andirons h. 27½ / **$1,400** ($1,540) / est. $1,500-2,500 / 10-21 Christie's.

667. Pipe tongs, wrought iron, probably New England, late 18th c., l. 20¾ / **$850** / est. $200-400 / dealer / provenance: Harry Arons, Antiques, Ansonia, Conn. / 9-30 SPB.

Metals

669. Two kettles, brass and wrought-iron, 19th c., h. 5¾ to 6¼ / **$175** / est. $200-400 / 2-4 SPB.

670. Gate, cast-iron, marked "S. Baker 2d, No 4, 1855, Weeman 26 Merrimac St Boston," 28½ x 42 / **$320** ($352) / 10-21 Christie's.

671-672. Presentation medal, gold, inscription reads "The National Guard, 27th New York State Artillery, To La Fayette, Centennial Anniversary of the Birth Day of Washington, New York, 22nd February, 1832" (sold together with the book *History of the Seventh Regiment of New York, 1806-1889* by Col. Emmons Clark), h. 6¼ / **$26,000** ($28,600) / no catalog estimate / Winterthur Museum / provenance: the Marquis de La Fayette in direct line to owner; discussed in Clark / 10-21 Christie's.

Specialty

234 Specialty

673. Weathervane, copper, late 19th-early 20th c. / **$180** / 9-12 Phillips.

674. Weathervane, pine, iron patches, h. 20 / **$175** /est. $400-600 / 11-18 SPB.

675. Weathervane, copper, late 19th-early 20th c., l. 28 / **$180** / 9-12 Phillips.

676. Weathervane, copper, late 19th-early 20th c., h. 26½ / **$300** / est. $250-350 / 1-31 Phillips.

Specialty

677. Weathervane, sheet iron, 19th c., 11¼ x 7⅜ / **$400** / est. $400-500 / 11-18 SPB.

678. Weathervane with directionals, copper, late 19th-early 20th c., l. 30 / **$500** ($550) / est. $700-900 / 10-21 Christie's.

679. Weathervane, sheet iron, streaks of red, yellow, and green paint, 19th c., h. 20 / **$650** / est. $500-700 / 11-18 SPB.

680. Clockwise: Rooster weathervane / **$140**; fish sign / **$400**; cow weathervane with directionals / **$600**; horse weathervane / **$300** / 7-7 Withington.

681. Weathervane, gilded copper, circa 1840, h. 20½ / **$1,500** / est. $1,500-2,000 / 11-18 SPB.

682. Weathervane, gilded copper and zinc, ears missing, possibly by J. Howard, West Bridgewater, Mass., circa 1855 / **$2,300** / dealer / 5-6 Julia.

683. Weathervane, copper, traces of gold leaf and paint, early 20th c. / **$1,400** / est. $2,000-2,500 / 9-22 Skinner.

684. Weathervane with directionals, gilt copper, late 19th-early 20th c., l. 38 / **$800** ($880) / est. $800-1,200 / 10-21 Christie's.

Specialty

685. Decoys, Mason's Decoy Factory, Detroit, Mich. Left to right, top to bottom: merganser drake, standard grade, tack eyes, o.p. with some wear and retouching / **$350** /est. $200-300 / ex-coll. Stanley Murphy, Mass.; merganser hen, standard grade, tack eyes, o.p. somewhat worn / **$320** / est. $175-250 / ex-coll. Murphy; merganser hen with crest, challenge grade, o.p. evenly worn / **$700** / est. $300-400 / ex-coll. Murphy; black duck, challenge grade, o.p. worn, cracks, chips / **$100** / est. $100-150; black duck, Detroit grade, o.p. excellent / **$140** / est. $100-150; redhead drake, standard grade, o.p., some retouching and repair / **$1,000** / est. $150-250; scaup hen, premier grade, glass eyes, o.p. worn, heavily shot hit / **$150** / est. $75-125 / ex-coll. Murphy; scaup drake, challenge grade, glass eyes, o.p. evenly worn / **$180** / est. $100-150 / ex-coll. Murphy; merganser with crest, premier grade, o.p. stripped, body refinished / **$280** / est. $150-250 / ex-coll. Murphy; widgeon drake, premier grade, o.p. rough, body rough / **$280** / est. $100-200; oversize black duck, challenge grade, glass eyes, p.r., weight removed / **$175** / est. $125-175; hollow-carved mallard drake, premier grade, glass eyes, o.p. worn, splits, chips, separation, weight removed / **$270** / est. $150-250 / 7-11 Bourne.

686. Decoys, ex-coll. Stewart E. Gregory, Conn. Top to bottom: owl, balsa, glass eyes, virtually unused, Herter's, Inc., Waseca, Minn. / **$450** / est. $300-500 / private; crow, glass eyes, unused, Chas. H. Perdew (1874-1963), Henry, Ill. / **$450** / est. $300-500 / private / 7-12 Bourne.

687. Decoys, the Ward Brothers, Chrisfield, Md. Left to right, top to bottom: golden-eye drake, o.p. excellent, slight wear, weight removed, signed by Lem and Steve Ward, circa 1940 / **$900** / est. $2,000-3,000; redhead hen, balsa, excellent condition, unweighted / **$800** / est. $600-1,000; life-size Canada goose, signed by Lem Ward, dated 1976 and with poem by Ward, unused condition / **$1,700** / est. $3,000-5,000 / 7-11 Bourne.

688. Decoys, Maine. Left to right, top to bottom: golden-eye hen, traces of o.p., in-use repaints, Monhegan Island, circa 1920 / **$45** / est. $75-125; golden-eye drake, good weathered o.p., circa 1920 / **130** / est. $75-125; primitive scoter, old but probably not o.p. / **$30** / est. $50-100; redhead drake, o.p. worn evenly except head / **$45** / est. $50-100; white-winged scoter, bill repaired, otherwise excellent condition, Monhegan area, early example / **$900** / est. $1,000-2,000; scaup drake, in-use repaints (head recent), weight removed, Camden / **$40** / est. $50-75; squaw drake, in-use repaints, some splits, unweighted, Casco Bay area / **$40** / est. $50-100; redhead drake, carved wings and eyes, some o.p. and in-use repaints, small chips and splits, head possibly altered, Gus Wilson, Casco Bay / **$160** / est. $100-150; white-winged scoter, glass eyes, almost unused, weight removed / **$50** / est. $150-250; white-winged scoter, tack eyes, o.p. excellent, unweighted / **$60** / est. $100-200; scoter, hollow construction, some age splits / **$120** / est. $200-350; primitive merganser, o.p. very worn, some dry rot and splits, circa 1920 / **$90** / est. $75-125 / 7-11 Bourne.

689. Decoys, ex-coll. Stewart E. Gregory, Conn. Left to right, top to bottom: brant, tack eyes, o.p. excellent, unweighted, Jos. W. Lincoln, Accord, Mass. / **$2,600** / est. $1,000-1,500; Canada goose gosling, tack eyes, hollow carved, some retouching, clean break in neck repaired, weight removed, Sam Soper (1875-1942), Barnegat Bay, N.J. / **$1,000** / est. $1,000-1,500; Canada goose gosling, tack eyes, minor retouching, break in neck, Soper / **$1,000** / est. $1,000-1,500; Canada goose, glass eyes, appears unused, unweighted, Lincoln / **$1,050** / est. $500-750; Canada goose, very weathered, circa 1900 / **$500** / est. $300-500; Canada goose, hollow carved, fine o.p., Barnegat Bay, N.J., area / **$400** / est. $400-600 / 7-12 Bourne.

Specialty

690. Decoys, ex-coll. Stewart E. Gregory, Conn. Left to right, top to bottom: two red-breasted mergansers (hen and drake), remains of comb feathers, excellent condition, unweighted, both signed by Jim Thurston, Maine / **$1,500** / est. $500-1,000; primitive merganser, carved comb and eyes, probably o.p., some cracks, signed "RW[illiams]" / **$900** / est. $500-750 / provenance: coll. William J. Mackey, Jr.; merganser hen, glass eyes, cork body, weathered o.p., light shot hit, probably L.I. or Conn. / **$300** / est. $300-500 / provenance: coll. Mackey; red-breasted merganser hen, carved wings, some repairs and retouches, weight removed, possibly L.I. / **$1,300** / est. $500-800; red-breasted merganser hen, rawhide comb, excellent condition (minor crack), weight removed, possibly L.I. / **$3,300** / est. $600-900; canvasback hen, balsa, glass eyes, weathered and worn o.p., weight removed, Ward brothers / **$700** / est. $300-500; canvasback drake, balsa, glass eyes, weathered and worn o.p., weight removed, Ward brothers / **$600** / est. $300-500; scaup drake, traces of o.p., Ward brothers, circa 1925 / **$1,600** / est. $500-1,000 / 7-12 Bourne.

691. Martha's Vineyard merganser decoys, ex-coll. Stanley Murphy, Martha's Vineyard (to be illustrated in forthcoming book *Martha's Vineyard Decoys* by Murphy). Left to right, top to bottom: red-breasted drake, made in three parts, glass eyes, some o.p. wear, small chip, light crack, Frank Richardson, Edgartown, Mass. / **$450** / est. $300-500; red-breasted drake, somewhat weathered o.p., possible retouches, Benj. D. Smith (1866-1946), Oak Bluffs, Mass. / **$1,500** / est. $400-600; American drake, strong traces of o.p., small gouge, split, chip, Keyes Chadwick (1865-1958), Oak Bluffs, Mass. / **$900** / est. $400-600; red-breasted drake, hollow carved, glass eyes, bold but weathered o.p., Richardson / **$800** / est. $350-600; red-breasted drake, one glass eye missing, very old paint, some in-use repaints, small chip, weight removed / **$1,700** / est. $500-800; red-breasted drake, glass eyes, worn o.p., end of bill and tail replaced, Smith / **$1,600** / est. $250-400 / 7-12 Bourne.

692. Decoys, ex-coll. Stewart E. Gregory, Conn. Left to right: Canada goose "stick-up," single cast-iron foot, hollow carved, glass eyes, excellent o.p., Chas. Schoenheider (1854-1944), Peoria, Ill. / **$6,500** / est. $1,500-2,000; Canada goose, tack eyes, excellent condition, Jos. W. Lincoln (1859-1938), Accord, Mass. / **$1,550** / est. $600-900; Canada goose, glass eyes, weathered o.p. with some retouching, weight removed, Lem Ward, Md., circa 1930 / **$1,200** / est. $1,000-1,500 / 7-12 Bourne.

693. Great blue heron decoys. Left to right: made in three removable parts (body, neck, head), traces of old bluegray paint, possibly Absecon, N.J., area, circa 1870, h. 66 / **$2,000** / est. $1,500-2,500; in three parts (body, neck and head, and bill), scant traces of o.p., possibly Beach Haven, N.J., area, circa 1900 / **$3,700** / est. $1,500-2,500 / 7-12 Bourne.

694. Shorebird decoys, ex-coll. Stewart E. Gregory, Conn. Left to right, top to bottom: Hudsonian curlew, excellent o.p., light shot hit on right side, carved "M" on bottom (William Matthews, Assawaman Island, Va., / **$2,000** / est. $400-600; plover, probably o.p., excellent condition / **$200** / est. $100-200; Hudsonian curlew, excellent o.p., some weathering, detailed feather pattern, John Dilley, Quogue, L.I., N.Y. / **$10,500** (ties record) / est. $3,000-5,000; primitive curlew, carved wings, excellent condition / **$300** / est. $400-600; plover, excellent condition / **$170** / est. $100-200; willet, glass eyes, balsa, excellent o.p., some mars / **$350** / est. $300-500 / 7-12 Bourne.

Specialty

695. Two life-size swan decoys, tack eyes, several repaints, age splits / **$400** / est. $1,000-2,000 / 7-12 Bourne.

696. Two curlew decoys, age splits and minor damage, late varnish, New England, 19th c. / **$3,200** / private/ 9-14 Julia.

697. Carved shoe, pine, possibly Penn., probably late 19th-early 20th c., l. 8 / **$230** / 4-8 Theriault.

698. Carved eagle and flag from steamboat pilot house, pine, paint decorated, New England, 19th c. / **$800** / New Hampshire Museum / 7-7 Withington.

699. Carousel horse, pine, 19th c., l. 47 / **$900 ($990)** / est. $600-800 / private / 10-21 Christie's.

700. Cigar-store Indian, old paint in shades of red, yellow, blue, brown, and olive, 19th c., h. 40 / **$2,300** / 5-5 Garth's.

701. Cigar-store Indian, red, yellow, and blue paint, 19th c., h. 62½ / **$5,750** / est. $700-$1,000 / private / 11-18 SPB.

702. Life-size wooden figure of John Dickinson, paint decorated, restorations, possibly William Rush, Philadelphia, 1787-90, h. 70 / **$10,000** / est. $25,000-35,000 / exhibited at Dickinson Mansion, Dover, Del., 1962, and The Smithsonian Institution, 1963 / 11-18 SPB.

703. Carousel horse, wood, original paint, 19th c., 44 x 59 / **$3,800** / est. $2,000-2,500 / 9-22 Skinner.

704. Life-size redhead drake, all original, signed on back "A. E.[lmer] Crowell, *Maker*, Cape Cod, Mass," East Harwich, 1862-1952, plaque 13 x 23½ / **$2,500** / est. $2,000-3,000 / 7-11 Bourne.

705. Carved rooster, pine, paint decorated, attributed to Wilhelm Schimmel, Penn., 1865-90, h. 5½ / **$1,400** ($1,540) / est. $1,500-2,000 / private / 10-21 Christie's.

Specialty

706. Toy ice wagon, painted cast-iron, made by Kenton Hardware Co. (Kenton, Ohio), 1920, l. 15 / **$155** / 10-21 Ralston.

707. Toy "Central" train set, locomotive, tender and four coaches, tin and cast-iron, like-new condition, l. 28 overall, circa 1900 / **$250** / 10-21 Ralston.

708. Toy, "Crandall's Great Show, The Acrobats," wood with lithographed paper, original box and instruction sheet, circa 1880 / **$200** / 10-21 Ralston.

709. Toy "Dexter" horse painted tin, made by George Brown Co. (Conn.), 1880, l. 9¼ / **$200** / 10-21 Ralston.

710. Toys, cast-iron. Top to bottom: "City Ambulance," made by Arcade, 1920, l. 6 / **$110**; baby Lincoln touring car, made by Williams, 1933, l. 6½ / **$260** / 10-21 Ralston.

711. Toy horse and rider, painted tin, made by Fallows Co. (Philadelphia), 1885, 10 x 8 / **$285** / 10-21 Ralston.

712. Toy, "The Barrel Walker," wood and lithographed paper, with original box, made by Ives, 1890 / **$300** / 10-21 Ralston.

713. Toy Chrysler Airflow automobile, pressed steel, rubber tires, made by Kingsbury Toy Co. (Keene, N.H.), 1934, l. 14 / **$250** / 10-21 Ralston.

Specialty

714. Cast-iron banks, late 19th c. Left to right, top to bottom: mechanical "Always Did Spise a Mule, Pat'd. Apr. 27, 1897," worn o.p., tail broken, spring replaced / **$175**; mechanical owl, worn o.p. / **$215**; still "Bank," worn o.p. / **$25**; mechanical "Always Did Spise a Mule, Pat'd. Apr. 22d, 1872," worn o.p., coin hole cover damaged / **$265**; mechanical "Punch and Judy Bank, Buffalo, N.Y., U.S.A.," worn o.p. / **$300**; still clown, worn o.p., some rust / **$32**; mechanical lion and monkey, worn o.p., significant damage / **$45**; still soldier, worn o.p., new connecting screw / **$7**; mechanical "Wurlitzer," very worn o.p., not working / **$40**; mechanical house and dog, traces of paint / **$205**; still lion, worn o.p. / **$25**; still horse, worn o.p. / **$90**; still football player, very worn o.p. / **$60**; mechanical building, traces of o.p. / **$270** / 3-17 Garth's.

715. Toy rowers, painted cast iron, oars missing, made by Wilkins Toy Co. (Keene, N.H.), 1890, l. 10 / **$475** / 10-21 Ralston.

716. Toy police patrol, painted cast-iron, made by Hubley Mfg. Co. (Lancaster, Pa.), 1915, l. 15 / **$700** / 10-21 Ralston.

717. Toy "Yankee Notions" pedlar wagon, stenciled and painted tin, two opening lids for merchandise, made by George Brown Co. (Conn.), circa 1870, l. 15 / **$1,175** / 10-21 Ralston.

718. Toy fire patrol, painted cast-iron, made by Dent Hardware Co. (Fullerton, Pa.), 1905, l. 22 / **$420** / 10-21 Ralston.

719. Toy oxen pulling log with black driver, painted cast-iron, made by Kenton Hardware Co. (Kenton, Ohio), 1915, l. 14½ / **$310** / 10-21 Ralston.

720. Toy dump cart and horse, painted and stenciled tin, made by Fallows Co. (Philadelphia), 1890, l. 16 / **$260** / 10-21 Ralston.

Specialty

721. Stuffed "mammy" doll, chain stitched eyes, leather high-button boots, 19th c., l. 27½ / **$500** / est. $200-300 / 2-1 SPB.

722. Toy clockwork "walking doll," tin, papier mache, cloth dressed, with original box, h. 11 / **$775** / 10-21 Ralston.

723. Toy clockwork "Walking Zouave," tin, papier mache, cloth dressed, with original box, h. 11 / **$1,000** / 10-21 Ralston.

724. Scrimshaw doll, bone, h. 15 / **$1,000** / est. $300-500 / 11-18 SPB.

725. Mechanical, "Jonah and the Whale on a Pedestal," bank, late 19th c., h. 3 / **$18,500** (record for a mechanical bank) / 7-2 Roan.

726. Noah's ark toy, painted wood approximately 160 pieces, possibly Salem, Mass., circa 1810, ark 26 x 27 / **$1,100** / est. $600-800 / 4-29 SPB.

727. Toy artillery, painted cast-iron, made by Pratt and Letchforth, Buffalo, N.Y., circa 1890, l. 34 / **$9,500** / private (future museum) / 10-21 Ralston.

728. Handmade working model of an 1865 American 4-4-0 steam locomotive, "Bangor," tin plate, brass, and bronze, original paint and storage box, Maine, 19th c. / **$2,400** / est. $2,000-2,300 / 9-22 Skinner.

729. Toy horse and carriage, painted tin, cloth dressed figure with papier mache head, clockwork mechanism in working order, made by George Brown Co. (Conn.), circa 1870, l. 16 x h. 11 / **$2,400** / private / 10-21 Ralston.

730. Toy soldiers and bell, painted tin and cast-iron with clockwork and bell, made by Althof, Bergmann, New York, circa 1876, marked "Chime and Design Patd. May 19th 1874," l. 10 x h. 10 / **$3,200** / private (future museum) / 10-21 Ralston.

Specialty

731. Wooden butter prints, probably Penn., 19th c. Left to right, top to bottom: thistles, turned handle, 5¼ x 3¼ / **$145**; leaves, turned handle, dia. 3½ / **$55**; pinwheel and four eagles, refinished, dia. 4 x l. 8¾ / **$330**; sheaf of wheat, dia. 3½ / **$125**; cased snowflakes, handle missing, 3½ x 8 / **$65**; cased cow (machine dovetailing), 5¾ square / **$85**; star, large handle, dia. 4 / **$115**; eagle, dia. 4 / **$135**; semicircular heart, turned handle, l. 7 / **$295**; cased pineapple, stave construction with pewter bands / **$70** / 5-5 Garth's.

732. Wooden butter prints, probably Penn., 19th c. Left to right, top to bottom: cased thistle and rose, worm holes, dia. 4¼ / **$57.50**; heads of wheat, dia. 5 / **$45**; cased strawberries, dia. 4½ / **$85**; star, varnished, dia. 5 / **$27.50**; flower age cracks, dia. 3 / **$25**; swirl handle damaged and worm holes, dia. 4 / **$55**; cow, dia. 3¾ / **$105**; cased swan, dia. 4½ / **$85**; star / **$65** / 4-7 Garth's.

733. Wooden cookie mold, carved in reverse with the arms of New York State, stamped "J.V. Watkins N.Y." in all four corners, 11 x 11 / **$550** / est. $600-800 / 2-1 SPB.

734. Ladle, burl walnut, dia. 6½ / **$140** / dealer / 4-8 Theriault.

735. Wooden bowl, 18th-19th c., l. 56 / **$450** ($495) / est. $600-800 / 10-21 Christie's.

736. Burl bowl, probably New England, 18th-19th c., dia. 17½ / **$700** / est. $600-800 / 4-29 SPB.

737. Scrimshaw wart hog tusk, inscribed "Aaron Pratt, Harpoonman, 1804," probably from African coast whaling ground, l. 7½ / **$550** / est. $300-400 / 11-18 SPB.

738. Powder horn, inscribed "Jonathan Barnes, His Horn, May 4th, 1776, Concord," l. 15¼ / **$1,600** / est. $1,500-2,000 / 11-18 SPB.

Specialty

739. Scrimshaw, 19th c. Left to right: whaling scene covering about 70% of tooth, light blue water, excellent condition, h. 8 / **$1,600** / est. $1,200-1,800; many figures completely covering tooth including a man, an owl holding a rabbit, a woman, an osprey holding a fish, an eagle, and two whales captioned "The Narwhal" and "The Whale," excellent condition, h. 8½ / **$1,800** / est. $1,200-1,800; pair of teeth, sides shown have a sailor and a woman representing America, sides not shown have urns of flowers, minor imperfections, h. 6⅞ and 6⅝ / **$2,200** / est. $1,500-2,000 / 8-2 Bourne.

740. Scrimshaw whale tooth, l. 6½ / **$2,200** / est. $1,500-2,000 / provenance: Israel Sack, Inc., N.Y. / 11-18

741. Scrimshaw, 19th c. Top to bottom: whaling scene with ship flying English flag, inscribed at the tip "The tooth of a sperm whale. Captured by Captn McCarty in the North Atlantic Ocean Augst 10th 1852 . . . in the Barque Adventure," signed "W.L. Roderick," minor imperfections, l. 7½ / **$3,300** / est. $1,000-2,000; American eagle holding banner reading "1841 U.S.A.," engraved in black, red, green, and blue, minor imperfections, l. 7⅛ / **$900** / est. $500-800; American ship (shown), other side has full-length portrait of a woman, minor imperfections, l. 6⅝ / **$1,000** / est. $500-800 / 8-2 Bourne.

742. Scrimshaw powder horn, panoramic view of Philadelphia, inscribed "Wilm Reynolds Anno Domini 1778," l. 12½ / **$5,750** / est. $3,250-3,750 / private / 2-19 Sloan.

743-744. Pair of scrimshaw whale's teeth, top tooth shows the capture of the *Essex* and the *Enterprise* and the *Boxer* engaged in battle, bottom tooth shows the surrender of Ft. Griswold (Conn.) and an "Abolition Meeting," top tooth signed "H. Comings," minor imperfections, 19th c., l. 9⅝ and 10¼ / **$9,000** / est. $3,000-5,000 / provenance: the family of William Phillips and Son, whale ship agents, New Bedford, Mass. / 8-2 Bourne.

Specialty

745. Ships' document boxes, 19th c. Left to right, top to bottom: "Ship Young Phenix," painted green / **$600** / est. $300-500; "Schr. M. Vernon.," painted light and dark brown, contains several documents and records / **$550** / est. $200-300; "Rodman.," grain painted / **$300** / est. $200-350; "Bark Josephine.," tin, flaking paint, contains two smaller boxes and several envelopes / **$100** / est. $200-300; "Ship Midas.," grain painted / **$450** / est. $300-500; "Magnolia.," grain painted / **$250** / est. $200-300 / 8-2 Bourne.

746. Sail maker's bench, completely equipped, all original, 19th c., l. 55¾ / **$700** / est. $500-700 / 8-1 Bourne.

747. Whale hunting equipment, 19th c. Top to bottom: blubber pike, original handle / **$125** / est. $100-200; deck spade, marked "L. Cole" / **$200** / est. $100-200; deck spade converted from bone spade, original handle, marked "Peters" and "Cast Steel" / **$200** / est. $150-250; cannon-fired harpoon / **$400** / est. $300-500; harpoon, handle split / **$50** / est. $50-100; toggle harpoon / **$200** / est. $200-300; toggle harpoon, some rust / **$150** / est. $200-300; harpoon gun, brass, Eben Pierce, serial no. 4 / **$900** / est. $1,000-1,500 / 8-2 Bourne.

748. U.S. Army drum, ash, paint decorated, lower drum head and leather tighteners missing, labeled on interior "Manufactured by Horstmann Bro's & Co., Military Furnishers, Fifth and Cherry Streets, Philadelphia," circa 1865, dia. 16¾ x h. 15½ / **$525** / est. $500-650 / 9-22 Skinner.

749. Half-hull model of a sailing ship, laminated wood, original paint decoration, minor imperfections, 19th c., l. overall 71½ / **$1,900** / est. $1,000-1,500 / 8-1 Bourne.

750. Fireman's equipment, 19th or 20th c. Left to right: belt / **$55**; helmet / **$90** / 9-14 Julia.

751. U.S. military shako, leather and brass, visor needs restitching, circa 1835, h. 9¾ / **$750** / est. $500-700 / 9-22 Skinner.

752. Fireman's trumpet, tin, paint decorated, 19th c. / **$265** / 9-14 Julia.

753. Pair of fire buckets, leather, painted green, inscribed "John A. Tucker, Dorchester, No. 1," circa 1800, h. 12¼ / **$1,100** / est. $1,200-1,500 / 2-4 SPB.

Specialty

756. Group of apple barrel stencils, 19th-20th c. / **$75** / 9-14 Julia.

754-755. Log book of two whaling voyages of the ship *Alpha* (8 Aug. to 31 Dec. 1837, and 3 June 1838 to 30 Nov. 1841), final voyage ends at Holm's Hole (Edgartown, Mass.), includes watercolor drawings, whaling stamps, and lists of whales taken, well preserved, spine worn / **$5,000** / est. $2,500-4,000 / 8-2 Bourne.

758-759. Walking stick, ebony and gold, head inscribed "J A McClernand to Hon. A Lincoln June, 1857," collar inscribed "Presented to Revd. Jas. Smith, DD late pastor of First Presbyterian Church of Springfield, Ills. by the family of the late President Lincoln . . . 27 April, 1868," collar inscribed "Bequeathed by the Revd. Dr. Smith, US Consul Dundee, to the Right Hon. John Bright M.P. . . . ," l. 36¼ / **$9,000** / est. $7,000-9,000 / 2-4 SPB.

757. Twenty-four-hole candle mold, pewter and pine, early 19th c., 23¼ x 18 / **$575** / est. $450-550 / 11-18 SPB.